W9-CLH-745

Andrew Wyeth

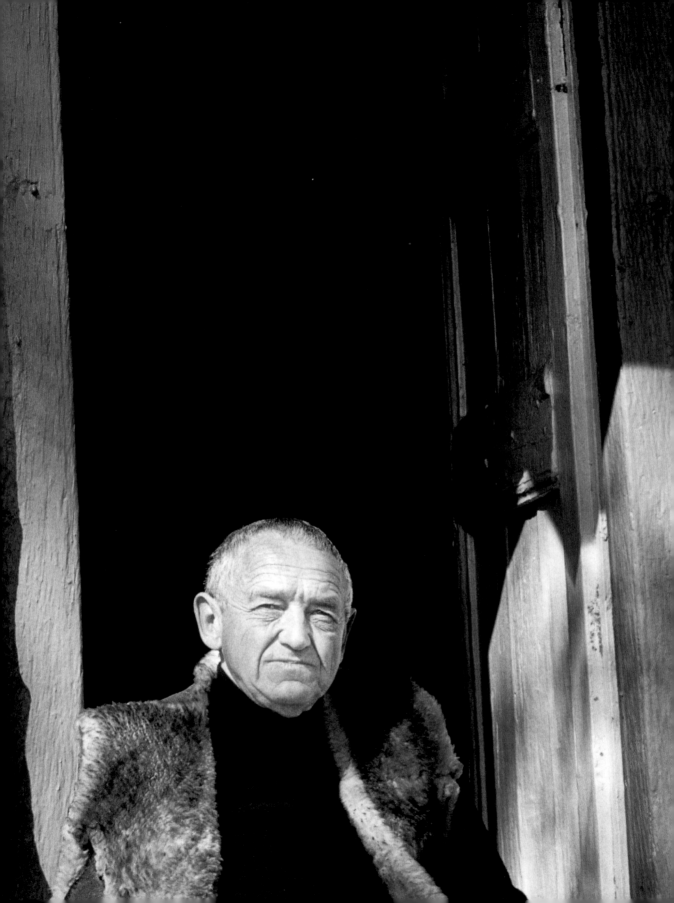

Andrew Wyeth

A SPOKEN SELF-PORTRAIT

Richard Meryman

Selected and arranged from
recorded conversations with
the artist, 1964 – 2007

NATIONAL GALLERY OF ART, WASHINGTON

D.A.P. / DISTRIBUTED ART PUBLISHERS, INC.

Andrew Wyeth: A Spoken Self-Portrait is issued in conjunction with the exhibition *Andrew Wyeth: Looking Out, Looking In,* at the National Gallery of Art, May 4 – November 30, 2014. The exhibition is made possible by Altria Group.

Produced by the Publishing Office
National Gallery of Art, Washington
www.nga.gov

Judy Metro, *editor in chief*
Chris Vogel, *deputy publisher/production manager*
Wendy Schleicher, *design manager*

Designed by Chris Vogel and edited by Ulrike Mills with Tam Curry Bryfogle

Sara Sanders-Buell, *permissions manager*
John Long, *assistant production manager*

Typeset in Arno Pro and Cronos Pro
Printed on 157 gsm Snow Eagle by C & C Offset Printing Co., Ltd., Shenzhen, China

Copublished by
D.A.P. / Distributed Art Publishers, Inc.
155 Sixth Avenue, 2nd Floor
New York, NY 10013
Tel: 212-627-1999
Fax: 212-627-9484
www.artbook.com

Unless otherwise noted, all works are by Andrew Wyeth.

Library of Congress Cataloguing-in-Publication Data
Andrew Wyeth : a spoken self-portrait / Richard Meryman. — 1st edition.
 pages cm
"Selected and arranged by Richard Meryman from recorded conversations with the artist, 1964 – 2007." Includes index.
ISBN 978-1-938922-18-3 (alk. paper)
1. Wyeth, Andrew, 1917 – 2009 — Interviews.
2. Painters — United States — Interviews.
3. Wyeth, Andrew, 1917 – 2009 — Friends and Associates — Interviews. I. Meryman, Richard, 1926 – editor of compilation. II. Wyeth, Andrew, 1917 – 2009, interviewee. Interviews. Selections.
ND237.W93A85 2013
759.13 — dc23 2013027022

DISPLAY IMAGES
frontispiece: Peter Ralston, *Meeting*, photograph of Andrew Wyeth, 1980
facing page 1 as well as pages 6 – 7, 104 – 105, 118 – 119, and endpapers: photographs of Andrew Wyeth's studio
page 8: *Christina's World* (detail), 1948, tempera on panel, The Museum of Modern Art, New York, Purchase
page 28: *Last Light* (detail), 1988, watercolor on paper, Greenville County Museum of Art, Gift of Richard and Bessie Epes in honor of Frank E. Fowler
page 46: *Cooling Shed* (detail), 1953, tempera on panel, The Philadelphia Museum of Art, Marvel in memory of Gwladys Hopkins Elliott, 1998
page 64: *Pentecost* (detail), 1989, tempera on panel, private collection
page 84: *Spring Fed* (detail), 1967, tempera on panel, private collection

10 9 8 7 6 5 4 3 2 1

Contents

Introduction

In the fall of 1964, I sat in the living room of Andrew Wyeth's home in Cushing, Maine, interviewing him for an extensive article for *Life* magazine. On the floor, my tape recorder was secretly running. After twenty minutes of exploring the wellsprings of his art, this famously reclusive, complex man suddenly said, "You know, I won't be able to say these things again." I confessed that the tape recorder had been on. His response: "Thank God!"

From that instant I had tacit permission to tape Andrew Wyeth, openly or unannounced, during car rides, long walks together, telephone calls, formal interviews, family occasions, shared breakfasts — culminating over four decades in some four hundred hours of recorded conversations that explore the subtle intricacies, circumstances, imaginings, and emotions that informed his work.

Wyeth was pleased with the *Life* article, as it was not yet another critic's interpretation of Andrew Wyeth. In it, he spoke plainly about himself. I had cut up the transcripts of the tapes, eliminating my questions and selecting the most revealing clips and significant sentences, and arranged them on a tabletop into a free-flowing monologue that tracked Wyeth's thoughts on discrete topics. I have used the same system on a grand scale to assemble the material for this book, which is vastly enriched by additional conversations recorded during my research for three subsequent Wyeth publications.*

When in 1990 Wyeth gave me permission to do a full-scale biography, I had reason to plumb the Wyeth core at greater depth. I continued taping our conversations but also conducted searching interviews with all those close to him: most important, his penetratingly perceptive wife, Betsy; his sisters, Carolyn Wyeth, Ann McCoy, and Henriette Hurd; their husbands and children; Wyeth's two sons, Nicholas and Jamie; plus the remarkable inner circle of neighbors and friends to whom Wyeth had introduced me — the hidden, intricate, under-appreciated folk who sparked his imagination and famously populated his work on paper, canvas, and panel. Among these, in Maine, were Ralph Cline; Wyeth's lifelong henchman and subject, Walt Anderson; as well as Christina Olson (of *Christina's World*) and her brother Alvaro. And in Pennsylvania, the ex-German soldier, Karl Kuerner,

* The publications were a monograph on Wyeth's paintings, a book on Wyeth for young readers, and finally a biography of the artist: *Andrew Wyeth* (Boston: Houghton Mifflin, Inc., 1968); *Andrew Wyeth,* First Impressions series (New York: Harry N. Abrams, Inc., 1991); *Andrew Wyeth: A Secret Life* (New York: HarperCollins Publishers, 1996).

whose subsistence farm adjoined the railroad crossing where Andrew's father, N. C. Wyeth, was killed in 1945.

My bond with Wyeth endured nearly half a century, until his death in 2009. I believe our connection in the beginning was partly based on his sense that I was equipped to fathom his fervid creative life. That first day in Maine, he remarked on the fact that we had both grown up under fathers who were dedicated realist painters. I told him that my father's career as director of the art school at the Corcoran Gallery of Art and as a go-to Washington portraitist had collapsed in 1935 under the pressure of modernism. My immediate reason for promoting this *Life* assignment was to please my father, who was deeply reassured by Wyeth's success.

Initially, there were "tests" I had to pass. Wyeth took me to visit Christina Olson on my first visit — I think to see if I could deal with her intensely eccentric Maine world. To Wyeth, I looked like the Russian author Boris Pasternak, a favorite of his beloved father's. He asked to paint my portrait, and of course I could not oblige, being on assignment for *Life* magazine. But when months later I arrived in his opposite universe, Chadds Ford, Pennsylvania, I found that he had told everyone Boris Pasternak's son was coming to visit. I played the role, even signing one of "my father's" books for Wyeth's mother. I suspect that my taping trickery may have awakened the ten-year-old scamp always latent within Wyeth.

Andrew Wyeth: A Spoken Self-Portrait offers a taste for the general public of the treasury of recorded conversations that will eventually be archived by the Andrew & Betsy Wyeth Foundation for American Art. Once fully transcribed, catalogued, and made accessible, these recordings — heard thus far by very few people — are destined to become a critical source for researchers and scholars. The annotations do not yet exist to provide citations for the raw materials I have assembled into the monologues for this book. My editors and I have worked to retain the spoken sound and pacing of Wyeth's speech, taking liberties in punctuating the passages, silently correcting Wyeth's errors of speech, and adding a few notations and footnotes for clarity.

In these taped conversations the speakers come alive. You hear Andrew Wyeth's human side, his digressions, colloquialisms, his laughter and anger, his fibs and fears. You realize the force of the emotions he poured into his paintings and hear him talk about his

inspirations — how a scene or a person could inflame his imagination, trigger a rush of recognition, and evoke an intense memory. Then would come weeks and months of strategies to preserve and transmit his emotions — the defining essence of his work — onto the flat surface of the picture plane. I once asked Wyeth how that came about. His simple answer described the beating heart of his genius. He said if you feel something strongly enough, the feeling travels down the arm and onto the panel.

Richard Meryman

Voices

The predominant voice in these narratives is Andrew Wyeth's, but mingled with it are those of family, friends, and neighbors in Pennsylvania and Maine, many of whom became the subjects of his art. Members of the Wyeth family and other speakers are briefly identified here.

ANDREW WYETH, Andrew Newell Wyeth, the artist, 1917 – 2009

ANN WYETH McCOY, sister of Andrew, 1915 – 2005

BETSY WYETH, née Betsy Merle James, married to Andrew, 1921 –

CAROLYN BOCKIUS WYETH, married to N. C. Wyeth, mother of Andrew, 1886 – 1973

CAROLYN WYETH, sister of Andrew, 1909 – 1994

HENRIETTE WYETH HURD, sister of Andrew, 1907 – 1997

JAMIE WYETH, James Browning Wyeth, son of Andrew and Betsy, 1946 –

N. C. WYETH, Newell Convers Wyeth, father of Andrew, 1882 – 1945

NAT WYETH, Nathaniel Convers Wyeth, brother of Andrew, 1911 – 1990

NICKY WYETH, Nicholas, son of Andrew and Betsy, 1943 –

WALT ANDERSON, Maine friend, subject

ELIZABETH BOCKIUS, sister of Carolyn Bockius Wyeth

JOHN CANADAY, art critic

RALPH CLINE, Maine neighbor, subject

EDWARD HOPPER, artist

ROBERT HUGHES, art critic

PETER HURD, artist, husband of Henriette Wyeth

ADAM JOHNSON, Pennsylvania neighbor, subject

HILTON KRAMER, art critic

ANNA KUERNER, married to Karl Kuerner, subject

KARL KUERNER, Pennsylvania neighbor, subject

LOUISE KUERNER, daughter of Anna and Karl Kuerner

JIMMY LYNCH, Pennsylvania neighbor, subject

JOHN McCOY, husband of Ann Wyeth

ALVARO OLSON, Maine neighbor, subject, brother of Christina

CHRISTINA OLSON, Maine neighbor, subject

HEN TEEL, Henry Teel; Maine neighbor, subject

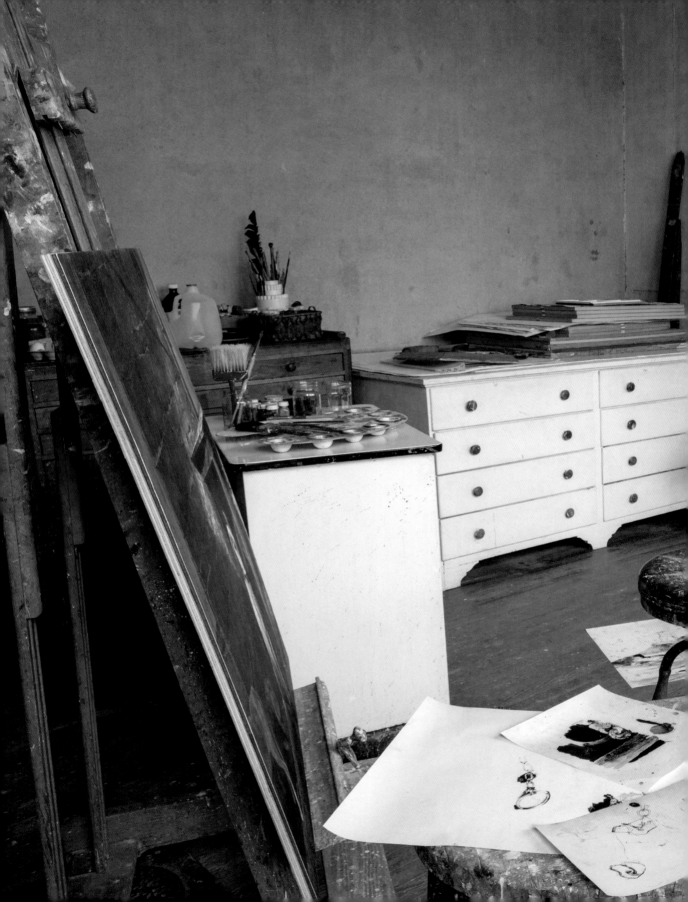

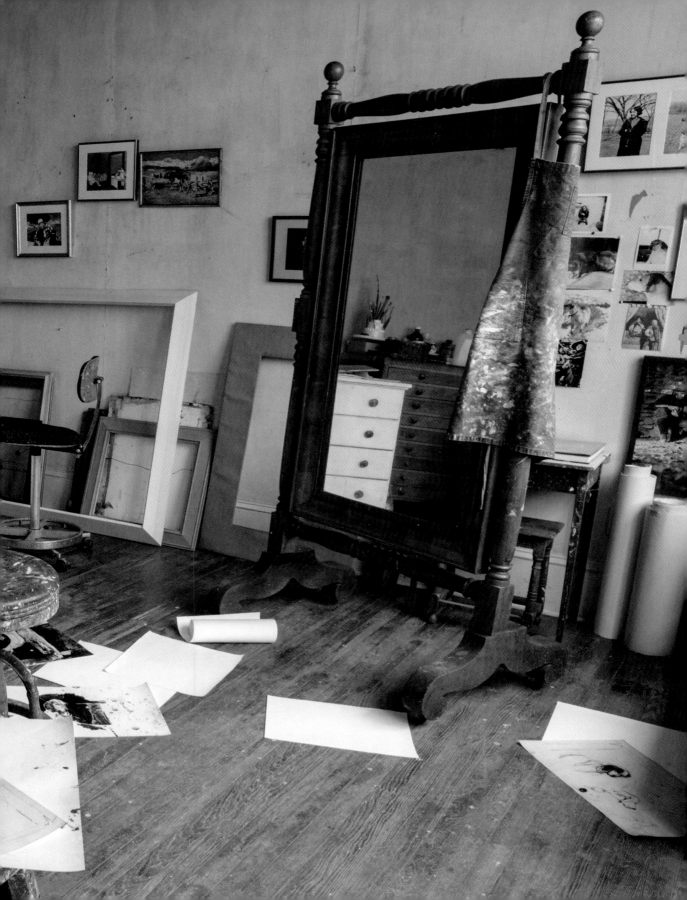

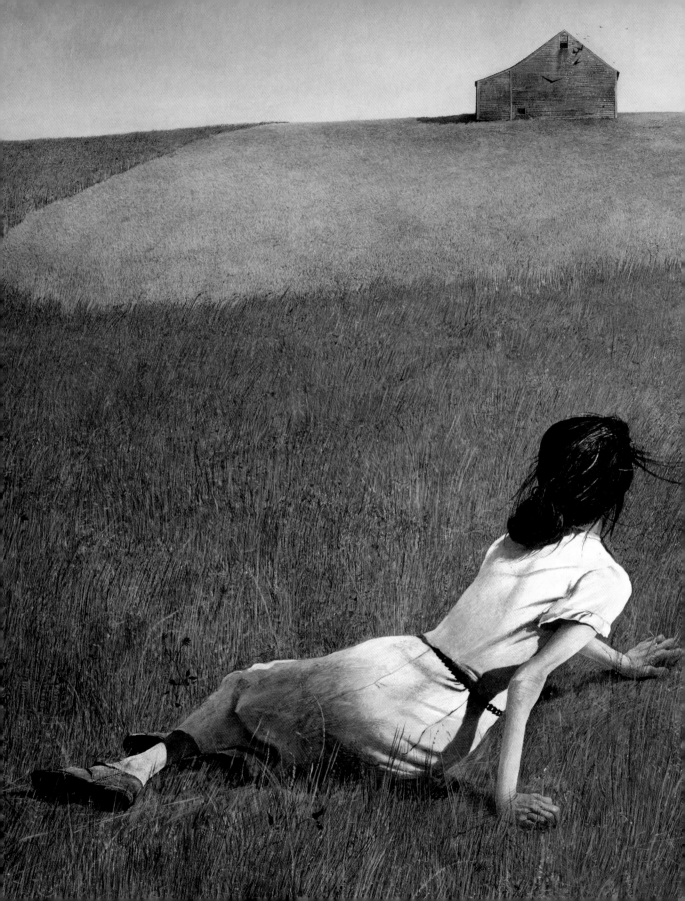

A STRANGE REALISM

I know people like to make me the American painter of the American scene. But I'm no more that than the man in the moon. I've created my own world the way I want it.

September 13, 1948

Dear Ma, I can't realize so much time has passed since you left. The reason for this is that I have been painting almost every hour of daylight on my tempera painting. I am so excited as I am certain this is my best work. Ma, I am quite certain that this time I have hit my top. All summer, for almost four months, I have been working on it and now I should finish it this week. No one has seen it, but living with it as I was, it has made me feel certain that it goes way beyond any other work. All summer I have been in a fog with its mood, so much so that to do anything else in the line of painting seemed stupid. I am so anxious for you to see it. I know Pa would be pleased in what I have been pushing after. God, Ma, everything I try to do is for you and Pa — and I won't let up one bit until I can drive it home.

> *All my love to you Ma,*
> *Andy*

I hung *Christina's World* on the wall over the sofa — and nobody particularly reacted to it. I thought, "This is sure a flat tire." We had Christina and Alvaro to dinner and I was nervous. Nobody said anything about it and then she and I were alone for a minute. I asked her how she liked it. She took my hand and kissed my fingers. [In the end] Alfred Barr at the Museum of Modern Art bought it.

It was Betsy who first brought me to Christina. A friend of my father's, Merle James, invited me to visit him and I went on July 12, 1939, my twenty-second birthday. Betsy came to the door — this brown tanned girl with this black hair. She was in short shorts and high heels, VERY attractive. Suddenly I was only interested in Betsy. To impress her I told her I was going to the University of Pennsylvania medical school. I wanted to be a doctor.

BETSY WYETH: The moment I saw him something went "BOI-I-I-I-N-G!" He looked different than anyone I'd ever seen. He stayed for lunch and talked about things I'd never heard before — the light that came in on the floor. I never thought I'd find anybody that would feel that way. He wanted to see this area and on the seat of his car was a yellow pad with an ink drawing of the Grange Hall. I said to myself, "Somebody knows how to draw." He was a little theatrical, kind of glittery, and I

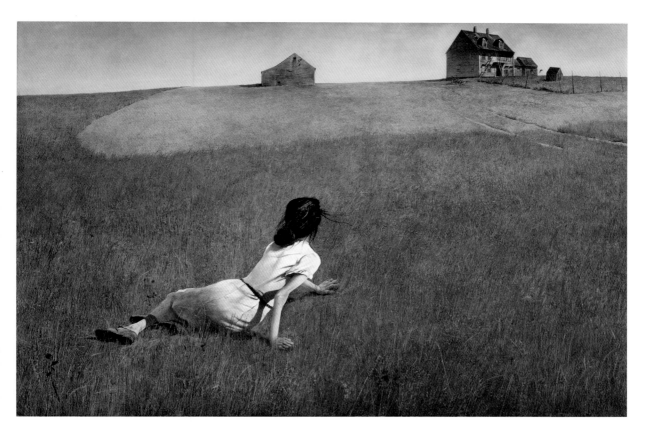

Christina's World,
1948, tempera
on panel, The
Museum of
Modern Art, New
York, Purchase

Engagement
portrait of Betsy
James, c. 1940,
Wyeth Family
Archives

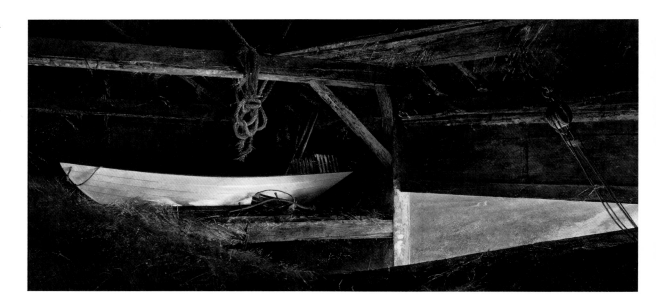

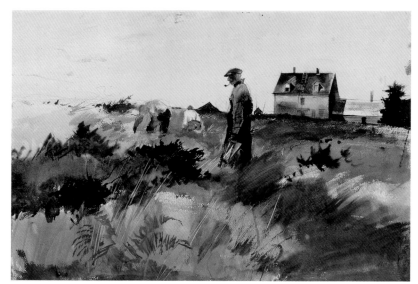

Hay Ledge, 1957, tempera on panel, private collection

Alvaro and Others, Raking Blueberries, 1942, watercolor on paper, Marunuma Art Park, Asaka, Japan

thought, "Hmm, this will be fun. I'll take him down to Christina." I wanted to see if he would go in the Olson house. A lot of people won't. The smell and odors. I judge people by it without saying anything.

He walked right into the kitchen to meet Christina. Was terrific, right away. So natural. He got by the first hurdle. We were married a year later. It's as if he hypnotizes you. He completely enters the most secret part of yourself.

That house and whole mood of it dawned on me slowly. Dry. Parched. Delicate feel. The Olson house is a dangerous thing to attempt because it's a little like the state of Maine itself. When you go there, you're captivated by the fish houses and lobster pots and roofs that sink in and everything is all Toonerville Trolley stuff. And then when you get through that crap, you might be able to see something.

The next year [1940] I'd go over there by boat early in the morning and stay all day. I did two watercolors — Christina's brother Alvaro working in his truck garden and another mowing a field. He had been a fisherman, but gave it up to take care of Christina. I painted the leftovers from Al's fishing and lobstering days scattered around and in the hay barn. His old dory was there. To me they were portraits of Al, things he inhabited. Now he kept a cow and horse and chickens and sold eggs and vegetables, hauled wood and raked blueberries in the field.

ALVARO OLSON: Lobstering is a pretty good job in the summer. Yup, like the water. No one talks.

In the kitchen Al would sit by the stove and Christina sat at the kitchen table. She couldn't walk anymore, and wouldn't have a wheelchair. The rear legs of her chair were worn short from hitching across the floor. She watched the world go by out the door and the window. There'd been a red fox crossing the snow and a bull moose in the fall. The summer people arrived and left. She had a telescope and kept track of the ships heading out to sea and worried about storms and waited for them to come back.

BETSY WYETH: I knew since I was ten that Christina needed me. Her polio hadn't crippled her, and she was very tall, very thin . . . delicate, absolute lady. I'd do her

hair, marvelous, coiled around her head, always dressed in pink or white, fresh flowers every day from her garden. Dainty. Pillowcases embroidered with field flowers. A white damask napkin in a basket of kittens. Walking, she'd lean on me, those bones hitting against my young bones. I'd help serve cakes and cookies to the Cushing ladies at evening "socials" in the front room. I didn't have a clue what was really going on.

Christina went through high school and had a very high IQ, amazing memory. She liked to talk about things in her life — the big schooners she saw launched in Thomaston. When she could still get around she'd traveled alone on boats and went to dances and Grange affairs with the other children and wore knee pads in case she fell. She remembered every hour of her two weeks in Boston seeing doctors who couldn't help her.

CHRISTINA OLSON: My great-great-grandfather on my mother's side was Captain Hathorn. This is Hathorn Point here. He built a house 'bout 1800 or something. His grandson was a captain of a clipper ship and he built it up, added the third floor, made it a boarding house. Used to be white. His daughter was my mother — Kate Hathorn. My father was John Olson, a sailor. Was Swedish, not a great talker. My first name is Anna. I was named for my Swedish grandmother.

I remember only one time that Christina said anything about being crippled. Somebody gave her a dark green dress with red fire engines on it and she said, "I don't dare wear it. People might consider me more of a freak than they do now. I suppose I am."

In the winter and cold New England mornings, their lives revolved around the stove. The wind blew through the cracks in the house. A man I painted said, "Heating that house is like heating a lobster trap." In the kitchen the three of us talked about how dry hardwood is better than pulp. My mental picture of Al is just cutting wood and bringing in the wood in the old wheelbarrow through the front door. And in 1945 I did a tempera of him in the kitchen with his oil lamp, looking like all the crows in Maine.

When I came face to face with Christina and that terrific reality, all my kid Dracula stuff [see page 43] seemed to be superficial. This was a much more serious thing. Severe. There's everything about that woman — her hand pushing a pie plate toward you or hitch-

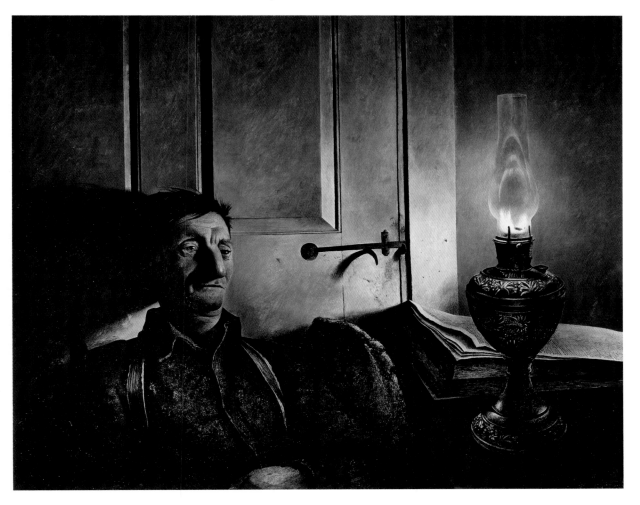

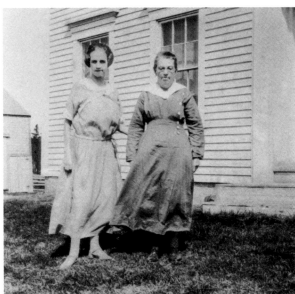

Oil Lamp, 1945,
tempera on panel,
Jamie and Phyllis
Wyeth Collection

Photograph of
Christina Olson
(left) and her
mother, c. 1920,
Courtesy of Mrs.
Jean Olson Brooks

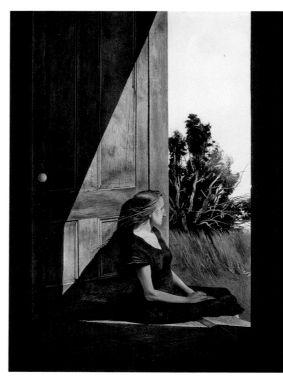

Christina Olson, 1947, tempera on panel, private collection

Wind from the Sea, 1947, tempera on hardboard, National Gallery of Art, Washington, Gift of Charles H. Morgan

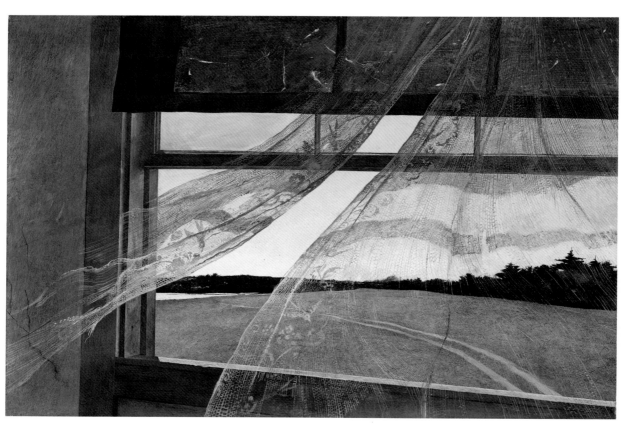

ing her chair across the floor so she can reach out with a poker to open the oven door to bake the pies and cakes. There's a strange feeling that, yes, you're seeing a thing that's happening momentarily, but it's almost a symbol of what's always happened in Maine. That's what makes that place, to my own personal feeling, so terrific.

I can honestly say that being crippled was not the part that made Christina remarkable to me. I didn't realize her arms were thin until I began painting her. Dignity is the thing. The dignity of Christina Olson. One of the strongest personalities I've ever known. When you get next to something as mammoth as Christina, all the dirt and grime and slight things evaporate. I never had a feeling of decay. I felt centuries in the past. You see before you the power of the queen of Sweden sitting there. Just being there she rules Cushing from that house, everything subordinated to her. In 1947 I painted her sitting in a doorway like a wounded gull. Her shadow against the door had a strange feeling, an eerie quality, almost eternity.

I was the only person allowed to come and go anytime.

ALVARO OLSON: He won't hurt nothin'. He ain't the foolish sort.

That summer in 1947 I was in one of the attic rooms feeling the dryness of everything and it was so hot I pried up a window. A west wind filled the dusty, frayed lace curtains and the delicate crocheted birds began to flutter and fly. The birds were as delicate as the real Christina. And ever since I was a small boy lying sick in bed, the movement of a curtain in the breeze thrilled me in a very strange way.

My whole idea is to keep myself open for the elusive something [that catches you] off balance when you least expect it. I drew a very quick sketch and had to wait for weeks for another west wind for more studies. You can't make these things up. You must see how it was. When I painted the tempera, I took the curtains to my studio to keep the sudden feelings alive. It's named *Wind from the Sea*. I get letters from people, and again and again they will say, "Well, that picture reminds me of when I was ill in bed as a child when I'd watch the curtain." They don't look at it as a painting. See, I'm not artistic, because they always tie it to when they were naive. They like me in spite of the fact of art.

The next summer I was in the attic finishing an indirect portrait of Al called *Seed Corn* — dry corncobs hanging from two ragged lines. I looked out the window and saw

Christina down below, crawling back from her tiny garden where she'd been picking berries. That evening I rowed my dory back to Betsy's parents' house and I kept thinking of Christina crawling like a crab on a New England shore, and I let her grow in my imagination. There was a dinner party, and I just put down my fork and got up and went into the barn and grabbed a piece of paper and in a few lines laid out what I'd seen. Then the next day I did a second study I'd drawn in my mind and imagination. It was all there. The final composition.

To really get excited — what is life anyway? It's excitement. You can make it out of nothing. Mine is a strange realism. It's the subjective beneath the surface that I'm after in painting — the truth behind the fact. I'm a queer combination of truth and non-truth. It becomes truth in my mind — which is more truthful than fact — at least to me. There's no rules in this except that I believe in the absolute nothingness of my own personality. I can't even tell you why I painted *Christina's World.* That's how elusive it is in my mind.

I set up my easel at the Olsons' in a little bedroom at the top of the stairs. All I need is just a room and an easel and the environment where I am painting. I wanted to be right in the surroundings. You inhale the quality and atmosphere.

For a week I just stared at that second study that I'd squared off onto a panel. When I'm doing nothing is when I'm doing the most. I think timing in painting is one of the most important things. I have no set way of starting a picture. I might put down one stroke on a bare panel — I don't want to put down too much because it freezes the idea. I want to keep it fluid while I dream about it. I want that momentary effect. I have such a strong romantic fantasy about things. You can have the technique and paint the object, but that doesn't mean you get down to the juice of it all. It's what's inside you, the WAY you translate the object — and that's pure emotion. So I put a lot of things into my work which are VERY personal to me. So how can the public feel these things? I think most people get to my work through the back door. They're attracted by the realism and sense the emotion and the abstraction — and eventually, I hope, they get their OWN powerful emotion.

GUEST BOOK AT THE OLSON HOUSE: After seeing reproductions all my life, then seeing the original, then coming here is like going to church all your life then going to the Vatican for the real thing — a very special and spiritual experience.

Reminded me of my parents' home. Haunting, sad, strong, lonely, proud.

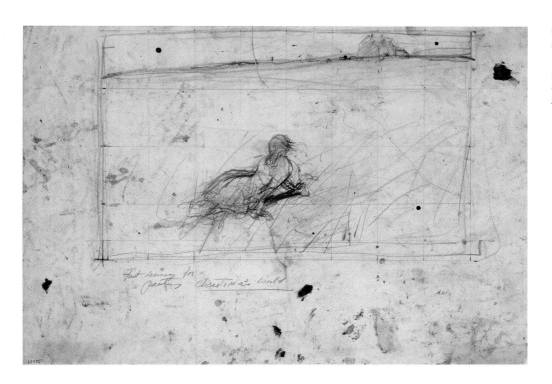

Study for
Christina's World,
1948, pencil on
paper, Marunuma
Art Park, Asaka,
Japan

19

A STRANGE REALISM

The quality of my work . . . sometimes I'm floating above looking down. Disembodied almost. *Christina's World* — I'm not standing there on the spot painting her. I've disappeared. In my best work there's a strange detachment. I've seen Olson's from the air on the way back by plane to Pennsylvania — that little square of a house, dry, magical — and I'd think, "My God, that fabulous person. There she is, sitting there." I feel the centuries in the past, an eerie quality, almost eternity — a symbol of New England people, an independent way of life. It's very hard for me to say it in words. If I could, I wouldn't paint it.

After a week I went down to the road and did a drawing of the house. That's all. I never went into the field. The picture is entirely a world of my imagination. I was building a real house — the clapboards and everything. Each little sill on the window. Imagining the tattered shades and curtains. I'd think, "Well, I've sat there and drawn from that window and here it is." I thought of Christina existing in that miniature house, not just Christina small size but a real one with an independent life of her own, going down through those different rooms, tiny little rugs.

That place to me is almost — that big building sitting up there — fourteen rooms — almost like a tombstone of the men lost at sea — the ghosts of lost sailors. Men [who] wore one gold earring. Al Olson told me once that one of his ancestors went flying off the rigging into the sea, pulled by a sail. Also the fact that the house when it was white was used as a beacon to ships off at sea. They'd see it gleaming up on that point.

To me there's a haunting feeling of people coming back to this place. A little witchcraft — spidery, giving the impression sometimes of dry, crackling skeletons rotting in the attic, dry bones. I know people like to make me the American painter of the American scene. But I'm no more that than the man in the moon. I've created my own world the way I want it.

The central struggle is to keep the initial excitement, so I drew the original quick study on the wallpaper. In that little room I worked on that hill for months. Al would sit on the little cot and light his matches on the wallpaper and smoke his pipe and fall asleep and wake up and say, "Well, you're gainin'." One day I was working and heard Christina call "Andy." I looked down the stairs and one of the spindles was out and I saw this plate of blueberry pie being pushed through and "Andy, here's your lunch." Getting there, pulling herself, amazing.

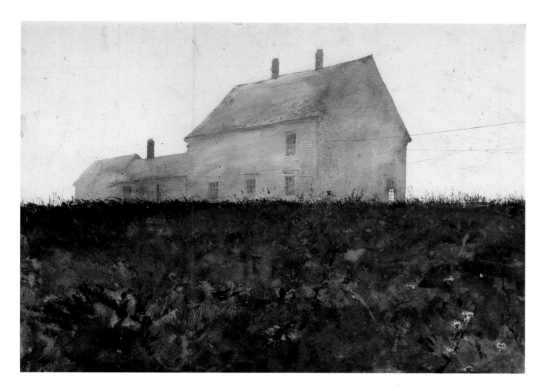

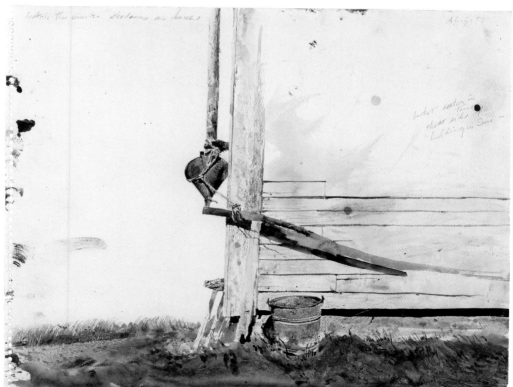

Olson House in Fog, 1967, watercolor on paper, Marunuma Art Park, Asaka, Japan

Downspout (Study for *Weatherside*), 1965, drybrush and watercolor on paper, Marunuma Art Park, Asaka, Japan

I was building up the ground — that grass — a strange quality that lifts it into another realm. Every blade was separately painted. Every blade of grass has its own character. You can't generalize; have a formula. The more you get into the textures of things, the less you have to clutter up the composition with a lot of props. When you lose simplicity, you lose drama, and drama is what interests me. I wanted to make the grass come toward you, a surge of earth, like the whole planet. I was building the planet that she was finally going to exist in — a living being there on a hill whose grass was really growing.

Sometimes you get so totally involved that the world you're creating on that panel exists in reality. It isn't something concocted. That's the excitement of tempera painting. I'm alone with a tempera for hours and hours. Through the months the intensity builds and builds until it's not a flat surface to me — until the painting itself is a living object and I live within the picture. I kept thinking what the air is that comes over Christina, and it comes over Monhegan and over Teel's Island — all the qualities. It's the air that my father saw in Needham, the breeze. It's all those things.

I could have easily sketched in Christina's figure. I liked the fact that she wasn't there. Someday she was going to be buried under that grass. Soon her figure was actually going to crawl across the hill in my picture toward that dry tinderbox of a house at the top. I felt the loneliness of that figure — perhaps the same that I felt as a kid. It was as much my experience as hers.

I got up enough courage to say to Christina, "Would you mind letting me make a drawing of you sitting outside?" I never want to change people from what they are, or change a landscape. I said, "Put anything you want on and come out." She picked out that pink dress. "That's my favorite dress, you know," she said. When I made studies of her arms and hands, my cold eye took in the deformity, and it shook me. I was shocked that her arms were so thin. I'd been so interested in her BEING, I hadn't thought about deformity. If you really are profound about a thing — see its essence — you don't have to have a prop like deformity. It's like putting clouds in the sky, adding little jingles to make interest. That just covers your inadequacy.

CHRISTINA OLSON: I never went down where I'm supposed to be in the painting. No, I was right out front the door in the yard here. I didn't have to go out so many times, maybe a dozen times or so, different days. Then he put it where he wanted. When he asked me to pose, at first I told him I didn't know. Of course, he kept talking and I agreed. When he wants to do a thing, it's pretty hard to refuse it.

I kept thinking about her in that pink dress being like a faded lobster shell like I find on the beaches there, crumpled, and I kept building it in my mind. Olson's was opening the door to the sea to me, of mussels and clams and sea monsters and whales. That's what I mean by dreaming. When it finally came time to lay in Christina's figure against the planet I'd created for all those weeks, I put this pink tone on her shoulder and it almost blew me across the room. And I painted a rag, like a blind eye, on the clothesline.

Christina's World is subdued, though it's quite hot in color — it's a sunny day. I've done an awful lot of experimenting. Christina's head underneath is gold leaf and painted over to get the burnished effect. I feel that the schematic coloring of a landscape — or even a portrait — has a lot to do with carrying the power of the mood. The color is all interwoven. The sky reflects in the head of the person — a portrait in a landscape and vice versa, back and forth. A unity.

I think I've caught that inner spark. Sometimes a sketch you can't enlarge on. It freezes. Then sometimes you can keep on building and keep on building and keep on building it, and it still retains that motion. And that's the thing. Christina in the field is definitely in motion with hair blowing out. Oh, it's a very fine line.

I painted Christina Olson in 1947 [see page 16] — she is sitting there with the kitchen door open and she's looking out into a foggy atmosphere that seeped into the tonalities of her skin and brought out the intensity of her eyes, the slight pinks around her eyelids, her mouth, the eye that's out of line — like that house. I could hear the Whitehead foghorn moan in the distance. When the sun would come out, the effect was of striking lights. It was all very real but it was almost the spirit of her — her mind going off. There was nothing detaining her. She had the quality of a Medici head. Years later in 1967 I painted Christina's portrait again — I called it Anna Christina.

I worked about five months on Christina's World. Then I did two direct portraits of her. One in 1952 was Miss Olson. She loved animals — she never had children, of course,

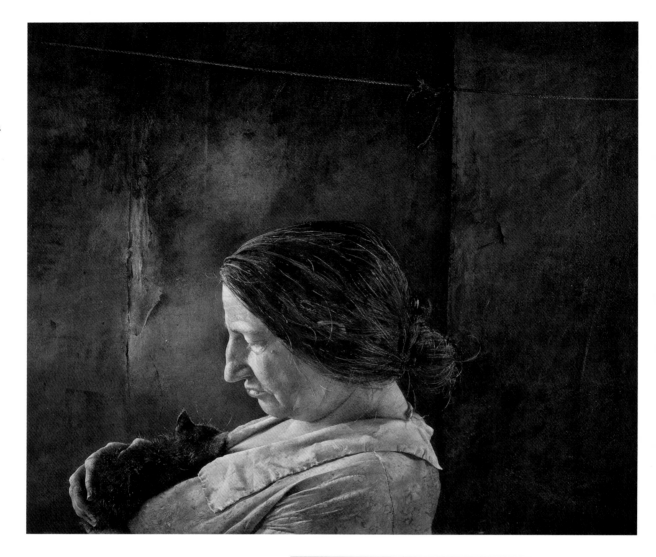

Miss Olson, 1952, tempera on panel, private collection

Photograph of Alvaro and Christina Olson with Andrew Wyeth, taken by Kosti Ruohomaa, date unknown, Courtesy of Kosti Ruohomaa/Black Star

and cats and dogs lived in the barn and came in through the door. One little kitten was special, slept on her bed, followed her when she moved. It was ill a couple of days. I love accident, the fact that one day she picked it up. So I painted the essence of this New England woman with her kitten, the love they shared — the fact that she was loving despite everything. I studied her face within inches, could feel its life.

> **BETSY WYETH:** The key to the Olson pictures is Andy's relationship with Christina — absolutely at ease with him. While she was posing, he said, "You have the most marvelous end to your nose, a tiny delicate thing that happens." He told me, "You should have seen the smile on her face. I've never seen anything like it." And he told me, "Al's got an awful lot of wood in the stove; it's very hot sitting there." With a cloth he carefully wiped all the corners of that great face, all around those little places, around the lips, the ears. He said, "I've never felt such delicacy. You know she's just like blueberries to me."

You can't make something out of nothing. Christina had a charisma there that just had to be unlocked. I'm just one of those strange collisions that happened. We were a little alike. I was an unhealthy child that was kept at home. When she couldn't walk anymore, she was kept at home. So there was an unsaid feeling between us that was wonderful, an utter naturalness. When we were alone we'd sit for a long time and not say a word, and then she'd say something, and I'd answer her. But when she said nothing she said the most.

> **CHRISTINA OLSON:** Andy's a very good friend. He doesn't talk nonsense.

I wouldn't know if *Christina's World* is one of my best pictures. It certainly seems to appeal to people. The challenge to me was to do justice to her extraordinary conquest of a life which most people would consider hopeless. If in some small way I have been able to make viewers sense that Christina may be limited physically but by no means spiritually — then I have achieved what I set out to do.

> **CHRISTINA OLSON:** The one of me outdoors… I guess it looks better back to than front to.

Alvaro Olson died on Christmas Eve in 1967. Christina died the following January.

"I went up there the day of her funeral. It was snowing. I happened to look into this kitchen. It had snowed hard during the night, and the snow had sifted in the cracks and chinks of the door so that there was a thin line of snow right across the floor right up over her chair and down. It was icy white, almost like a finger pointing. Damndest thing. God, the way the snow had sifted, very much how grain will sift through the finest sliver or opening. It was like lightning coming across the chair. I was wandering around and I looked into this dark room from the window and at the same time I could hear them using a jackhammer to dig the grave down there because the ground was so frozen, and I was shocked by that line of snow."*

* Andrew Wyeth quoted in Thomas Hoving, *Two Worlds of Andrew Wyeth: Kuerners and Olsons* (The Metropolitan Museum of Art, New York, 1976), 142.

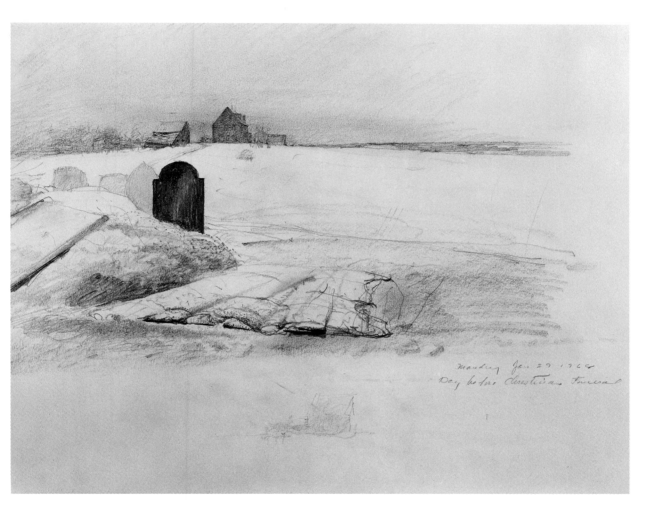

Christina's Grave,
1968, pencil on
paper, Marunuma
Art Park, Asaka,
Japan

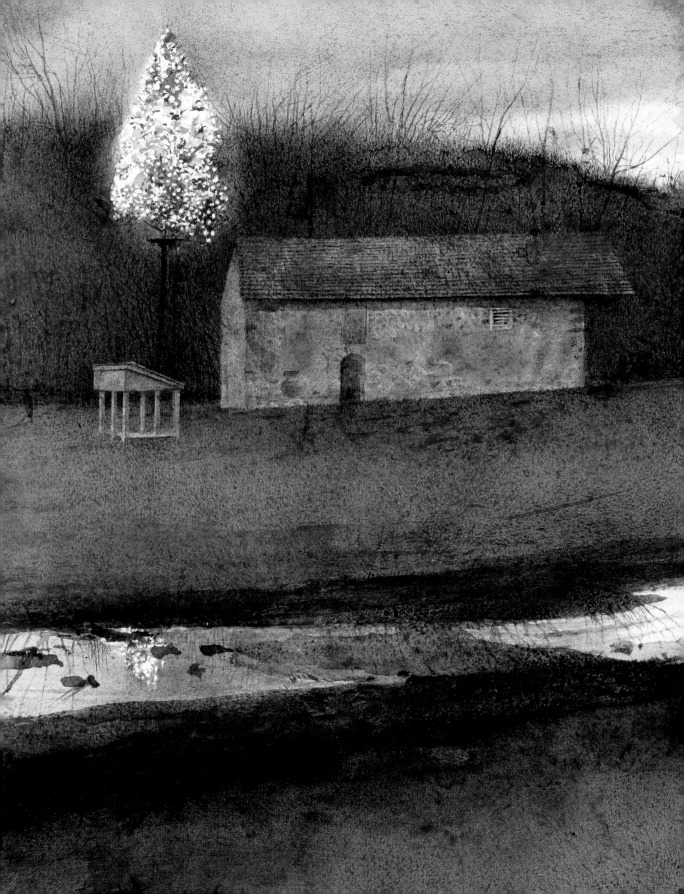

I built my own stories, and that is what painting has been to me. You don't have to paint tanks and guns to capture war. You should be able to paint it in a dead leaf falling from a tree in autumn.

I feel that I became an artist out of the life I led — things that appealed to me and really excited me — and then I began to paint. Like my father told me, "First live, then paint." Imagination was the most important — but never actually put into words. It sort of went along with everything. It was in the air.

> **PETER HURD:** The Wyeth place was like a beehive. Everybody working at something. Carolyn was drawing. Ann was fascinated with her dollhouse and playroom. Nat was building a castle and toy furniture. Andy was in the midst of the romance of Robin Hood and the knights of King Arthur. Henriette had just been commissioned for her first portrait. The family reminded me of a medieval guild.

> **ANN WYETH McCOY:** I can see Andy on his knees down in the playroom, moving his toy soldiers around, running trains back and forth, knocking stuff over. The soldiers he liked were the ones he'd dragged around, had red paint on them, bandages, shooting, terrific imagination. He'd hum. I guess it meant there was a lot of noise in the air and confusion. Terrible things going on. He'd make them die and he'd be dying, too — writhing and screaming, "Ooohhh." He was the soldier.
>
> We would run train tracks into old cardboard boxes, terminals sort of, all black and horrible. We would play "The Victory Ball" on the Victrola, tap drums rustling in the distance, then louder and louder until a crescendo. We could just see the soldiers, their helmets approaching the scary dark place and feel the confusion and terror of war. It was horrible. I wouldn't even put my finger on the tracks. Tremendous excitement out of nothing.

I would work out my own little life with my soldiers. They were real little people. I could see the smirk on their faces. A worn spot looked like a mustache or a wound in the side. I didn't think of them as small; just soldiers having a life of their own. It's like looking at an ant world below us. Working away. I'm god, hovering above, moving them around.

I loved it that I was in this miniature world, letting my imagination go. I built my own stories, and that is what painting has been to me. You don't have to paint tanks and guns to capture war. You should be able to paint it in a dead leaf falling from a tree in autumn.

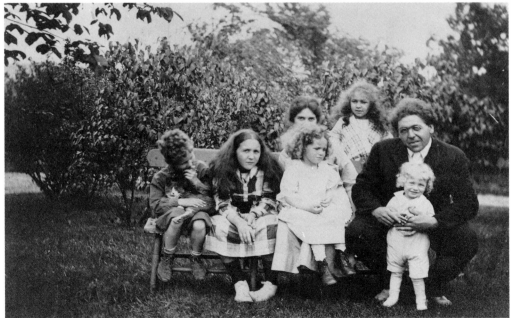

British at Brandywine, 1962, drybrush and watercolor on paper, private collection

Photograph of Wyeth family taken by Stimson Wyeth, c. 1919, showing (left to right) Nat, Henriette, Ann on mother Carolyn's lap, sister Carolyn, N. C., and Andrew in front, Wyeth Family Archives

Drawings by
Andrew and
N. C. Wyeth,
pencil on paper,
private collection

For me maturity has just been added on, not losing any of the childish wonder, the ability to be amazed. I'm not a big powerful painter doing great big forms. I'm not sure I can comprehend the big world. If I could put all my people I've painted in a room in the size I've painted them, little, it'd be marvelous. Go down and shake hands with all of them. Be terrific.

I was drawing mostly imaginary things — soldiers and knights. You learn an awful lot that way. Even as a young child Pa treated me like I might have been twenty years old. He'd say, "Now Andy, you wouldn't hold a rifle that way. Try to — now you're doing Braddock's men going through underbrush and walking down this road along the Monongahela River and [there's] deep foliage and the British soldiers marching, you know, in their regimental way. And in the deep foliage these Indians are waiting for them." And he said, "I want to get that silence of just the beating of the drums." And he'd make a drawing of the commander on his horse, very briefly, with the men of arms behind him marching, and maybe in the foreground just a feather would show. He'd get to the truth of it without a lot of . . . overemphasis. He was teaching me intuition.

He would make a drawing to show me a certain action of a figure — bending over with arms reaching — and it would hit me clear as a bell. He often said, "I wish more students of mine would catch on as quickly as you did." And he said he rarely saw anyone concentrate and be so oblivious to everything.

ELIZABETH BOCKIUS: Andy drew his grandmother when he was ten. He was fascinated by Albrecht Dürer. Andy would show a picture of Dürer's and say, "See that, the way the reeds come out of the water," as though he was discovering something new — a revelation to him. His mind was open and receiving everything, every impression. You could see his imagination in his eyes — far away. With Andy you feel as though the earth is always new.

I was the youngest of five children. I was sickly as a kid. Spindly. I had sinus trouble they treated by pushing wires with Argyrol up my nose. It turned out much later to have been tuberculosis. When I was four or five and got ill, Pa would sleep in the twin bed next to me, and I would wake up in the night with a nightmare and those big gentle hands and tapered fingers would be rubbing me with alcohol to lower my fever.

HENRIETTE WYETH HURD: Pa was always hovering over the children at night. Then he'd get up and nanny everybody again. He kept reins and lines on all of us. He was a kindly tyrant. He taught us to think for ourselves. Then when we began to, he hated it. Ma was a very shy woman. That household was very big to be in, and if you were quiet and well-behaved — and with that great giant hovering around — you didn't get many things said. I loved Andy. He was a good little boy, always busy, always bright. He seemed to be everybody's pet. Thin but always with a kind of fevered, charming energy. Pa painted his portrait but never could finish Andy's hands because they were never still. He was the sprite of the family. Always was and still is. Another spirit — elusive and elfin. Pixilated.

I'm a sneaky son-of-a-bitch and don't forget it. I used to crawl into the clothes hamper and watch women going to the bathroom. At a dinner party I told a dirty joke and screwed it up — which made it funny. Everybody howled. During the service in the church I hid behind a curtain and made faces at the congregation. I put Ex-Lax in the punch bowl. I did terrible things. I didn't give a damn. When I was painting *Her Room*, I was painting the doorknob and got close to study the thing — and it was me reflected, making the shape. So I painted myself in. I had a lot of fun with people, telling them, "I am in it."

I started out as a young boy drawing with a pen — a great deal of texture and detail. Then I started to do watercolors, too. I'd be working in the studio for six hours and then Pa would tell me to go out into the landscape and do something for myself. He used to say to me, "Andy, be like a sponge. Sop up experiences of life, and then don't forget to wring yourself dry in expression. Then absorb some more." I put in more time than anybody in their right mind would do. I was going to do it *right* or not at all.

The hardest thing for a young person is to see romance in the surroundings of the commonplace. That's where Winslow Homer was so remarkable — people playing croquet, dancing, playing cards. He lifted that into something larger. When I was thirteen Pa gave me a little watercolor set. I tried my first watercolor in the orchard, painting the studio. I was being rather too careful and my father said, "Andy, you want to explode on the thing. Free yourself." And he splashed watercolor onto the sky. I painted little watercolors that

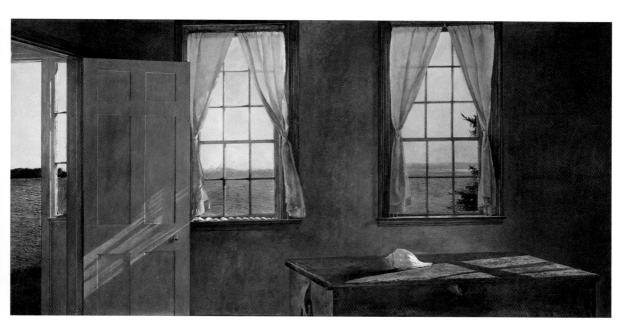

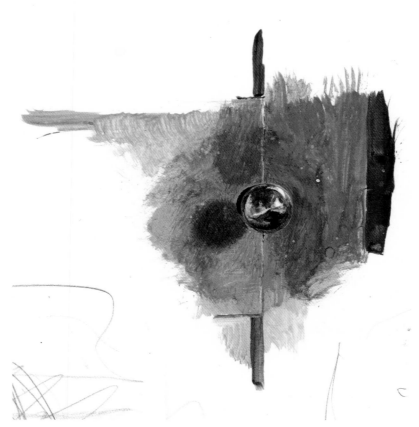

Her Room, 1963, tempera on panel, Collection of the Farnsworth Art Museum, Museum purchase, 1964

Study for *Her Room* (detail) with brass door knob showing artist's reflection, 1963, pencil and watercolor on paper, private collection

literally exploded, slapdash over my pages, and drew in pencil or pen and ink, wild and undisciplined.

I hated school. I convinced my parents that I'd die if I had to stay. My father said, "No top-notch artist ever graduated from college." I was always tutored until I was eighteen. Just left at home.

Pa talked to us kids about Shakespeare while he gave us castor oil. He loved to read to us, gave us books on Rembrandt and medieval history. He loved the piano and played Beethoven, Rachmaninoff, MacDowell. I think he could have been a pianist or a composer. We were brought up on Beethoven and Bach. Had a Victrola. Pa lowered himself into music as if he went slowly into water. He was rich in talking about Thoreau and Tolstoy and Conrad, who he was crazy about — who I am too. He'd take all of us on long walks over the countryside, looking for wild mushrooms or the first spring beauties. They were like the Holy Grail.

I surrendered to the world of my imagination. In Pa's studio there was a birch-bark canoe hanging from the ceiling, pirate chests, ship models — galleons, a four-masted brigantine — piles of *National Geographic*s, three death masks hanging on a wall, helmets and canteens, a gun, antique western saddles, Indian clothing, a papoose carrier, furs from trappers. Pa sat on an Indian drum to write his letters. I'd rummage through the back rooms and pull out his illustrations that he pooh-poohed and I loved, and bring them in covered with dust, and he'd turn around. "Oh, yes, I did that for such and such," and go back to work. I'd really study the picture and go through the drawers of proofs of his work.

ANN WYETH McCOY: Our mother allowed us children full freedom of the house "in any imaginative effort." In the big living room Carolyn would have a line of drawings along the floor from one room to another, under the piano and across. Andy and me were allowed to build theaters anywhere in the house. Andy divided the living room with the best blankets, rugs, anything he could find, with an opening to the theater. They'd be there for months.

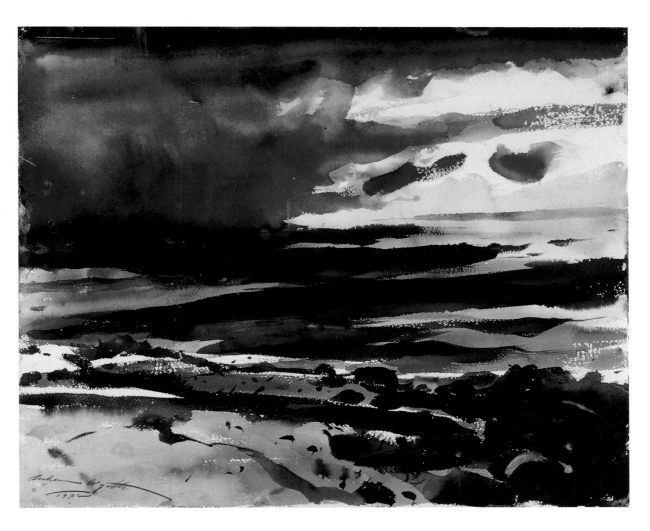

Coming Storm,
1938, watercolor
on paper, private
collection

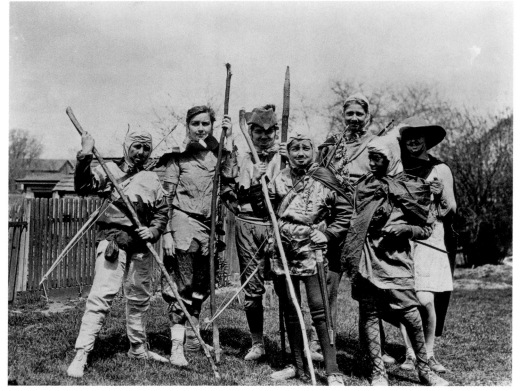

Castle Siege, 1932, pen and ink on paper, drawn at age fifteen, private collection

Photograph of Andrew Wyeth (center front) as Robin Hood, with sister Ann (third from left) and others as the band of "Merry Men," c. 1930, Wyeth Family Archives

HENRIETTE WYETH HURD: We'd say, "Oh, have you seen the new play Andy's done?"

The Scenes
ACT I — Robin's Home
ACT II — View from Nottingham
ACT III — Archery at Nottingham
ACT IV — In Sherwood Forest
ACT V — The Blue Boar Inn
ACT VI — Robin Hood and Guy of Gisbourne
ACT VII — Robin's Men and the King's Men
ACT IX — Death of Robin Hood

ACT I
My lady, don't you think it is high time for Robin to go in search of adventure?
Wy' yes my Lord.
Robin! Robin! I shall come at once my Lord.
Robin, I think you should go out into the world alone in search of adventure, a week from today you wilt go.

The woods became my Sherwood Forest and I *was* Robin Hood and some neighborhood boys were my henchmen. These boys would come home from school and I would sit down and tell them my ideas. It was sort of like building a painting. They were only thinking momentarily of it, and I had all day to figure out these adventures, just find excitement in the country the way Robin Hood did. We all had our bows and arrows and side arms, swords, horns. The more we carried the more we'd look like figures out of Howard Pyle or N. C. Wyeth. We reenacted all those wonderful stories my father read aloud to me when I was little. He'd showed every emotion — *Treasure Island,* Long John Silver, Billy Bones. Then he did Dracula. He scared me so I didn't sleep at night half the time.

When I was fifteen I did a theater production I called *The White Company.* The backdrop was a pen-and-ink panorama of a huge castle with an army of knights massed

along the enormous stone ramparts. Pa was impressed and told me to come into the studio every morning.

N. C. WYETH: It's time to rein him in. Give him some discipline, put a bit in his mouth.

I had a severe academic training. Pa said, "You've got to get down to the facts of things" — which was an awful shock to me. I wanted to express *myself*, not be spending half a day drawing cubes and cones and spheres and pyramids and drapery and white objects sitting on white paper. Then he got a skeleton and I made drawings from every position. And then after three months he removed the skeleton and said, "Draw me the skeleton walking, from memory." He taught me anatomy, made me draw from casts, brought in a nude model. He talked about how an eye is held in the socket, the brilliance of the liquid inside the eye. He talked about painting a sleeve — "Become the arm! Remember it inside." He talked about the quality of folds in a drapery and the way light comes across it. Pa started the wonderful idea of knowing what you paint — feel the hill, feel the tree, feel the pulse — it's like feeling the leg of the lady you love.

He was a great teacher — vitality, seeing things, feeling things very deeply. He never talked about how he would do anything. He tried to make you see the quality of the object, its depth, not impose his technique and tell you how it should be painted — describe a shadow over the sphere, the differences in gradations of dark to light to reflected light. . . the dark that was underneath, the one dark that might be left, and then into a smoky dusk. He did everything in his power to help me to see. Tying your painting to life, not something you do on a canvas and easel. You had to give it full power ahead or else you're out. He wasn't one to say, "This is great." He'd say, "This is a good start" or "needs some improvement." He did say, "Andy, you are more intense than anyone I ever taught."

My father once said, "Andy, you needed something to quiet you down at the end of the day so you could sit quietly in your studio and contemplate your work. I gave you a pipe to smoke and you just chewed the stem off."

He had great physical strength in his character, in his very body. He weighed almost 250 pounds, over 6 feet. He would stand and let my brother and me hit him as hard as we could in the stomach and just laugh at us, and that's when I was fifteen and Nat was

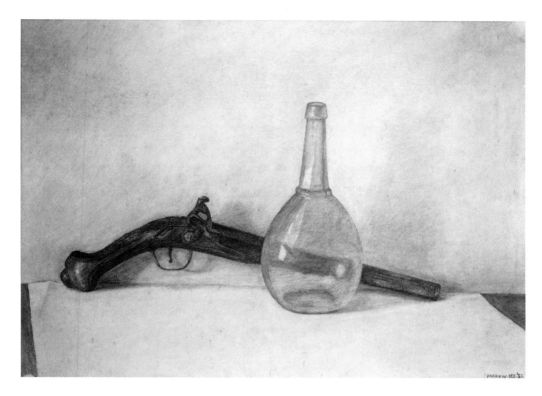

Pistol and Bottle,
1932, charcoal on
paper, private
collection

Photograph by
Edward J. S. Seal,
1930, showing
N. C. Wyeth
in front of his
mural of George
Washington's
reception in
Trenton on his
way to assume
the presidency of
the United States,
Brandywine River
Museum Research
Center (M. 44)

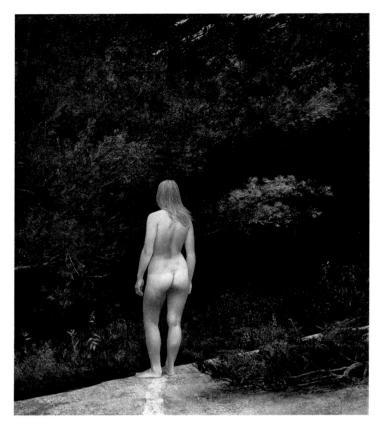

Indian Summer, 1970, tempera on panel, Collection Brandywine River Museum, Gift of John T. Dorrance, Jr., Mr. and Mrs. Felix du Pont, Mr. and Mrs. James P. Mills, Mr. and Mrs. Bayard Sharp, two anonymous donors, and The Pew Memorial Trust, 1975

Last Light, 1988, watercolor on paper, Greenville County Museum of Art, Gift of Richard and Bessie Epes in honor of Frank E. Fowler

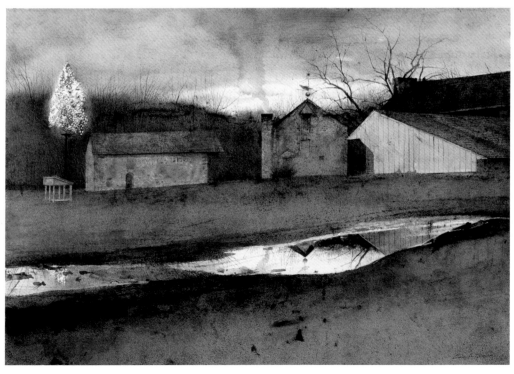

German things made of wax. That pudgy little face is Siri.* That's why she fascinated me. And in *Indian Summer*, that little husky figure of Siri looking off with that pale blond hair — it's the figure of that little revolving angel. That's what a primitive painter does — takes memories and makes them into a reality.

On Christmas Eve we hung our stockings at the end of our beds. I used to wake up in a sweat and reach out in the dark and feel for the bottom of the stocking, which would hang on the bedpost, and creep my hand up around it and feel those different shapes. Lying in the dark I could almost hear the sound of sleigh runners on the snow. Strange feeling. I'd finally fall asleep exhausted and then all of a sudden the house would shake — the spirit — the sound of sleigh bells — gave us pimples, really. Old Kris was always to me a giant plus a marvelous merry spirit, and also a huge terrifying giant. I could hear heavy boots stamping on the roof and a huge voice shouting at the reindeer to quiet down, and the sound of a huge bag dragged toward the chimney. Then I'd hear huge boots pounding up the stairs. I was frightened that he was going to come into my room, and I'd crawl down under my bedclothes and lie there shaking. Sometimes I peed in my bed and moved to the other side to dry it out. I'd hold my breath till my eyes would pop out. Horrifying. Magic. Anything that's good is terrifying, is sad. Christmas is joyful, sad, terrifying. I was sad it was over and glad it was over.

What I'm trying to get across is what makes things sublime, the difference between profound art and art that's just objects. You marry a girl, you love her and have all this amazing, romantic feeling of magic. Through the years that's apt to disappear. This is what Christmas is. It's magic. But you don't miss it until you've recovered it. That's the awful part. You don't know when you lose magic. Most of us have lost it about Christmas after we reach a certain age.

* Siri Erickson, the daughter of a local Finnish man, became a model for Wyeth in 1968 and represented for him "blossoming youth."

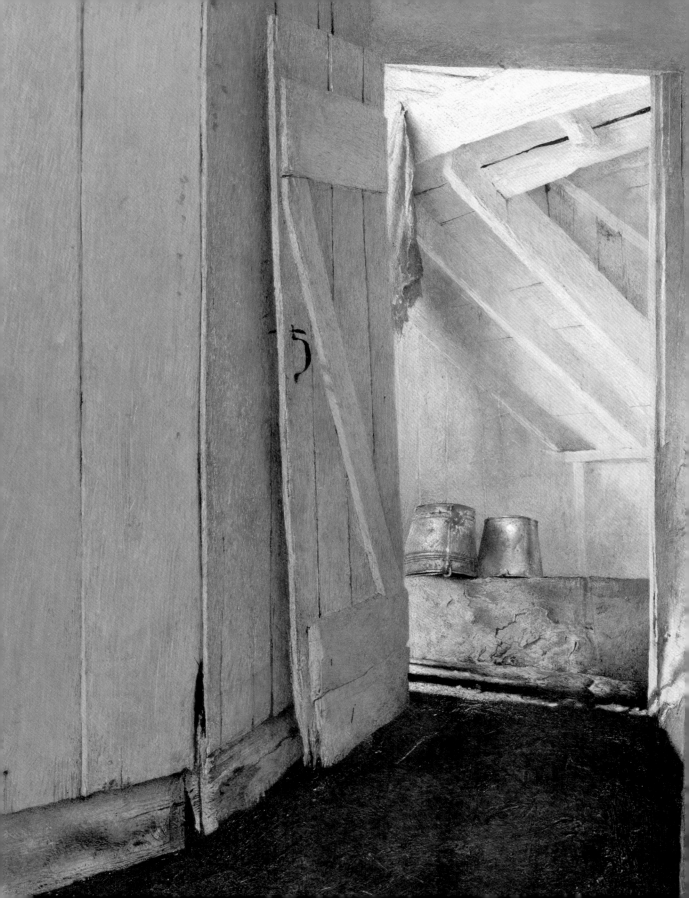

I'm a contradiction in painting. I'll start a different way every time — I have absolutely no set method of working. I'm very haphazard, really. To end up with pictures that are supposedly very immaculate and clear-cut — I probably have more in common with a Franz Kline than you realize.

Here I was, nineteen and sitting in the tide pools with mussels and rockweed and smell of salt air and flashing sunlight and clouds and shadows. I was just full of swashbuckling, painting for dear life, excited that I had all these colors. It was the pure excitement of my temperament — I didn't care whether it came off or not. I just wanted to put it down with no thought of anything. No worry about ruining a paper worth three and a half dollars. You paint what you are.

You've got to be a perfect ass to paint the way I do. My best watercolors are when I lose all control — gobs of paint and scratches and spit and maybe mud spattered against the sky. You start to clean it up and there's no life — just smooth things maybe done in the studio with a hairdryer to blow your washes.

I'd rather miss sometimes and hit strong other times than be an in-between person. If I lose this wildness, I'd be just a perfectionist. I certainly don't want to die without trying every means possible to get what I want. It doesn't matter if you stand on your head and use your feet if you get what you want.

I did as many as six watercolors a day and might get one or two that came off. People thought of me — I was a little halo boy, the white knight of American watercolor. Got to the point where I actually painted myself out. Then this other thing — tempera — showed up. Betsy came into the scene — who believed as I did and developed as I did, and it all merged into something deeper. Emotions really became the most important thing. It was a very strong turning point, got rid of the fireworks. And the critics hated it. Everybody thought I was wasting my time.

JOHN CANADAY: What is odd about Wyeth's reputation at both its extremes is that he has very strong virtues, all but unique to him in painting today, that are ignored by critics who should not be blind to them, and that a vast public cherishes his pictures for their reflection of a world that they reject in other art forms.[*]

[*] John Canaday, "Wyeth: His Nostalgia for a Vanished America Is Still a Best Seller," *The New York Times* (July 26, 1970): 79.

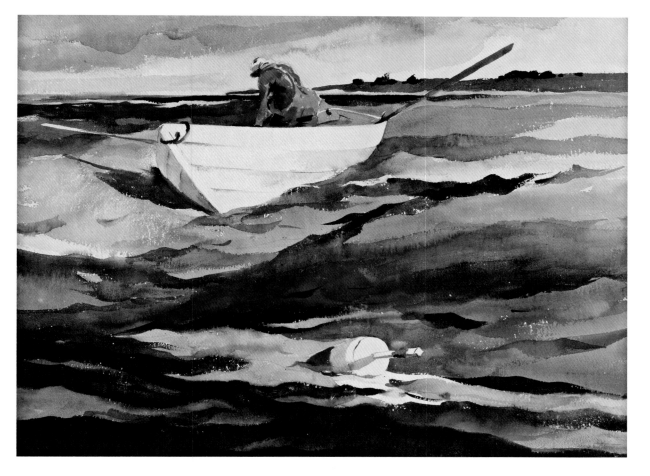

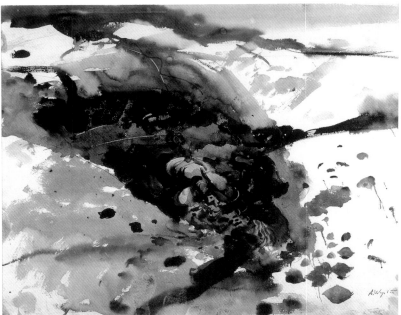

The Lobsterman, 1937, watercolor on paper, Hunter Museum of American Art, Chattanooga, Tennessee, Gift of the Benwood Foundation, 1976

Clump of Mussels, 1939, watercolor on paper, private collection

ROBERT HUGHES: If the most famous artist in America is Andrew Wyeth, . . . [it is] because his work suggests a frugal, bare-bones rectitude, glazed by nostalgia but incarnated in real objects, which millions of people look back upon as the lost marrow of American history.*

HILTON KRAMER: Mr. Wyeth . . . very adept at conveying sweet and solemn remoteness from the modern world and unafraid of indulging in an obvious, not to say shameless, sentimentality.†

I don't care about the critics. Well, it's as if I'm a young man in the middle of a fight. I'm not sitting back enjoying my laurels like an old man of art; they're treating me like I'm thirty years old and beating the shit out of me. I think I've had too damn much publicity to tell you the truth. People are beginning to hate me for it.

I've had a remarkable life. I've been very fortunate — early success and it lasted very long. I have no bitterness, because I've had everything. I've had all the important museum shows. I've gotten acclaim more than most people have ever gotten. And I'm not conceited about it. I'm just not part of the contemporary, not at all.

I think my work is out of step very definitely because I do what I want to do — not based on Jackson Pollock or anyone. I could go to all the social occasions but I don't think I'd be accepted. Fame is hard to deal with. I've just stayed away from it. If you get anything, you get it on the merit of your work, not because you kissed somebody's ass. I do what I want to do. I'm so much what I am, I'm a radical. Most painters don't care for me. I think I came along at a very right moment in American art. Realism was at a very low ebb — and that's where I was fortunate. I was alone. I was ahead of my time.

I've said that I consider myself an abstractionist. I am. I only judge my work through its abstract excitement — whether it has an essence. That's really where I tie up with Franz Kline; I like his large shapes — an interesting depth — very exciting. What is abstraction? It's just plain excitement. If you turn some of my most complete pictures upside down, you'll find an abstract. It's hidden by an absolute precision and

* Robert Hughes, "The Rise of Andy Warhol," *The New York Review of Books* (February 18, 1982): 6 – 10.

† Hilton Kramer, "Mammoth Wyeth Exhibition at Met," *The New York Times* (October 16, 1976): 15.

clarity — while underneath is the chaos that retains the flash of excitement that just burns. I often go in and look at my work at nighttime in the dark, and I can enjoy it for a completely different reason — the abstract quality.

People like to say Robert Frost is a bucolic poet. Just as people say I'm a painter of rustic scenes. That has nothing to do with it. Frost's strangely abstract meanings — he's an amazing witch doctor, spidery, flashy, dark and light all at once. People call me a realist. I'm my own personal vision of realism. I don't actually believe in realism. It has no life. So much can be said by so little; the less I put in a picture the better. It's what you *bring* to an object that *makes* it.

The young realists I know, most of them, all they do is photograph things and then paint them — change them around. I was accused in my earlier pictures of using photographic angles, but that . . . is perhaps a weakness of my work. Just as I feel sometimes in Hopper — a certain abstract quality that we rave about. He's pushing the extreme quality to make him abstract.

I paint fantasy, but come through realism to do it. Respecting the object is realism, sitting with it. Realism is a lid for emotion, creating super pressure beneath the skin of reality. Sometimes I spend months working on studies just to be in communion with a subject — often throw them into the back room. I feel the communion that seeped in from the unconscious will come out in a final picture sometime. With ease. Time really means nothing. The only thing that affects me is the sun up there, going across the sky. A watch has nothing to do with artists. I hate to feel anything on my hands, rings or anything bother the hell out of me.

I feel I've got to hang my dream world on as much truth as possible to save it from going soft. Realism is only a stepping stone into something deeper. My mood is hiding behind the mask of truth. I'm a queer combination of truth and non-truth that becomes truth — much more truthful than fact — at least to me.

To me — looking at a moving cloud, a soft vaporous cloud, behind a pine tree — it's the most abstract quality when you think of a thing growing out of the earth with these thousands of needles growing from the branch. It's fabulous! It's like a giant porcupine! You're looking at it like you've just been landed on this earth — holding your childish wonderment, plus the maturity you've gained from living and sadness and joys of love.

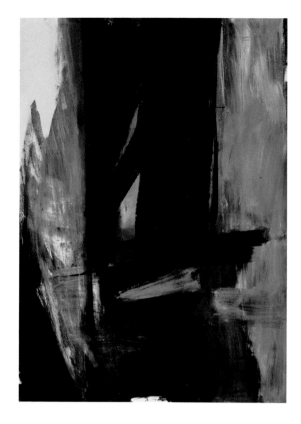

Franz Kline,
*Torches
Mauve*, 1960,
oil on canvas,
Philadelphia
Museum of Art,
Gift of the artist,
1961

The Intruder Study,
1971, pencil on
paper, private
collection

Thomas Eakins,
*Portrait of Mary
Adeline Williams*,
1899, oil on
canvas, The
Art Institute of
Chicago, Friends
of American Art
Collection, 1939

All I am is an instrument trying to tune in to that thing that's there. I like to go out into the landscape quietly—just sit there and see what there is that goes beyond the fact, and maybe work on a drawing or watercolor. Knowing a tree on a distant hill—even though you're painting it tiny—if you know the amount of branches on that tree, the feeling of the sound of the wind in it, you do paint it differently than if it's just something that's there. Maybe not in detail, but with authority and a real knowledge of its existence. It's something alive to you. If there's a post in a picture, I'll bring it into the studio, not to copy but to feel it.

This tree, you want to describe it to somebody who's never seen a tree. We take for granted that everyone has a smattering of knowledge, so we end up with a simulation or a vague generalized idea of a thing. That runs to blandness, finally. But if *every* part is detailed, there'd be no emotion. I'm supposed to be a great detailist. Actually I'm not, sections are.

If you want realism, look at Eakins, the most intense painter America ever produced. His pictures actually breathe in the frames. Mrs. Eakins came into the studio once and said, "Oh, Tom, that hand is beautifully painted. I've never seen you do it better." He took a palette knife and rubbed it right out and said, "That's not what I wanted. I wanted you to feel the hand." But his realism can be almost a preconceived idea of realism. His technique is very even. I mean you'll see a beautifully done eye and then the nose is put in—he wanted realism, yes. But you can't be like Charles Sheeler, every little thing delineated until it looks like [it was] put in Plexiglas. Oh, God, I've done it so I know. I go through stages where I think I've gone way too far.

My father used to say, "Andy, get your technique so good that when you feel something, you can express it without stopping to learn something. There's a constant struggle against your technique taking over and destroying emotion. It's all you see. Sargent is a good example. In early things of mine I would work on the ridge of a nose so smoothly it became a polished piece of metal. You can't have too much technique, but have it in reserve. I feel the object is the art, not what I make of it. When you begin to feel better than the object, that's the time to quit.

I'm always shocked by artists who feel *their* manipulation of nature is more important than nature itself, who think that a squiggly line is more important than a blueberry bush. If you know nature, you know how infinitesimal our abilities are. I think an

abstractionist actually feels [that] they are the creators, they're the gods. They would probably say that the greatest abstractionists are great organizers of details. They're in every square inch of the roughness. I can't believe it's organized if it's done in such a haphazard way. I think color is great and design is marvelous, but why can't there be some reality, too, so anyone can understand it.

Anything has to be out of control before it becomes good; then you haul it back in. Control is a wonderful thing, but if you go too far you get into the Ben Shahn type of thing that bores the hell out of me. Look at his work on Sacco and Vanzetti — effective pictures, but they look like cutouts, caricatures of nature. Leon Kroll, his conception of what a girl looks like — same eyes, again and again. That's the danger. They get a method of painting objects in so-called realism that has very little to do with realism. But it is academic. Everyone has been painting the same way. There's no life. Sheeler and Milton Avery, for instance, have wonderful patterns and design, but isn't the artist supposed to give out some warmth and texture and life within? I think design oftentimes kills an emotion.

I'm a contradiction in painting. I'll start a different way every time — I have absolutely no set method of working. I'm very haphazard, really. To end up with pictures that are supposedly very immaculate and clear-cut — I probably have more in common with a Franz Kline than you realize.

I think there must always be a quality of the unexpected in a thing. It's very important that you get off on it when you're a little off-balance, otherwise perfection starts too quickly. Maybe you'll put in a lot of filigree, but that first momentary spark will still come through. Before deterioration sets in, I'll drop my brush, turn my back quickly, and rush away, shut the door. I want to leave in a state of wondering. Then I have all night to dream of it and not be certain what I'm going to see the next morning. Then I can tell after one second whether it's crap or good. It's a very difficult thing to know just when you've lost your spirit and it's gone dead on you.

It's not the act of painting that exhausts me. It's pouring all my thought into an object. My God, I mean there's no end to — you really begin to peer into the things, a simple object, and realize the profound meaning of that thing. And if you have an emotion about it, there's no end. If you feel deeply about it, God, you can push it to the nth degree without shouting and screaming. I do an awful lot of thinking and dreaming about things in the past and future — the timelessness of the rocks and hills.

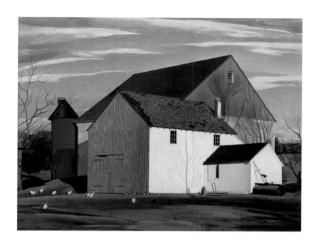

Charles Sheeler,
*Bucks County
Barn*, 1932, oil
on gesso on
composition
board, The
Museum of
Modern Art, New
York, Gift of Abby
Aldrich Rockefeller

Milton Avery,
*Bird and Breaking
Wave*, 1944,
watercolor on
paper, The Phillips
Collection,
Washington, DC,
Gift of Nora H.
Lichtenberg, 1991

Rock Island, 1975,
watercolor on
paper, private
collection

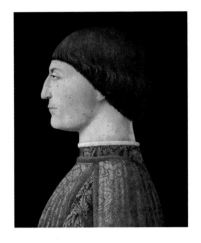

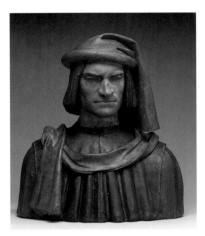

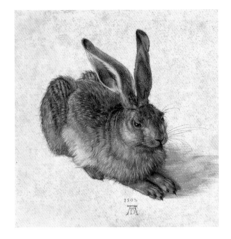

Piero della Francesca, *Sigismondo Pondolfo Malatesta*, c. 1451, oil and tempera on panel, Museé du Louvre, Paris

After Andrea del Verrocchio, *Lorenzo de' Medici*, c. 1478/1521, terracotta, National Gallery of Art, Washington, Samuel H. Kress Collection

Albrecht Dürer, *Hare*, 1502, watercolor and gouache, heightened with white gouache, Graphische Sammlung Albertina, Vienna

Maga's Daughter, 1966, tempera on panel, private collection

That's why I say you ought to lay in a picture in twenty minutes — get the feeling of the thing down as quickly as you can before it deteriorates into just cold mashed potatoes. Sometimes I put down one stroke on a bare panel to get the essence, that momentary effect before it freezes — purely an abstract line. When I'm very nervous, my hand makes the line vibrate, light and dark. If I lose it, I've lost something very important. If you placidly sit down with eyes of steel and hands frozen, you don't get emotion. I may look at that line for months. I feel that this communion will seep from the unconscious and come out in the final picture. All these moods go through me, building up before I even put anything down on the panel. Nothing is preconceived.

Sometimes I'll have a picture in my studio for months. It's marvelous because it's like a bone to go in and gnaw at. It's important to build up the intensity with undertone and dream about it, the core of the truth. I don't see it as a flat surface. I live within the picture. That's what I mean by dreaming. There may be blank spaces, but you have a window or a pile of rocks in the corner which are complete — and then vacancy — and it's amazing the things that dawn on one's mind. You start to get little nuggets here and little nuggets there and if you can draw them together, colors are interwoven. A unity. The sky reflects in the head of a person. You're not working *at* the painting. You feel like you're actually working in the valley. You're there. I have just about one interest in this world and that is trying to put into a painting all that I feel.

BETSY WYETH: It's all done through feeling. His memory of what a pine tree looked like as a child is connected to something else. The end of an eyelash and its relationship to some little place down in the corner of the background of the picture is terribly important to him. He'll talk about the white on top of that rock and its relationship to the light on that field. The size of the rock in relation to the size of the tree. And the whole feeling he is dealing with is how his grandmother would lie down and take a nap with him. He'd wake up and she'd be gone. He sensed size gone. These things are all assembled — I mean, with his mind — it's unbelievable to live this way.

I love Lautrec, Degas. Vermeer is a real master, but his work all looks the same to me. Piero della Francesca. Verrocchio's head of Lorenzo de' Medici. Brueghel, though I think he's somehow static. Dürer — you can feel the bone structure of his *Hare* under the skin, the haunches. Copley because he has such an amazing clarity. Constable very much. Lucian Freud — he's an odd one but he's interesting — got a quality. O'Keeffe was so afraid of sentimentality that it's all sentimental. Winslow Homer. His paintings have the quality of old figureheads on ships, a certain abstract quality. He had a great feeling for air in his work.

Picasso. He was a man of fireworks, a dynamo. Every minute he was the way I feel — constantly IN his painting. Some of his early portraits are really remarkable — the girl with the fan (*Lady with a Fan*), *Gertrude Stein*. He may make a crab that has ten legs, but it still looks like something that's moving along. *Three Musicians* in the Museum of Modern Art, an amazing piece of color and abstract shapes. He had some certainly remarkable periods. He was a man almost full of intuitions. A man of terrific force and influence. He's done some prime things. But not a great artist of all time. He did things indiscriminately. I think that for a great master he produced very few important pictures.

He started something. He really lifts things above the incomplete. But a good painting has to hit on all sides. I think it's got to have shapes that lift it, color that lifts it, emotion that lifts it to make it complete. That's why I think Picasso is important. He unlocked that abstract quality. He really lifted it above the mainstream. I think there's more hate than love in Picasso. Hate is his power. You got to have both; you've got to love as powerfully as you hate. He doesn't love the human being. He may have once.

With Rembrandt no matter what he did — a man or a pig — you feel he loved it, that it would roam the earth, that it had a spirit of its own. You look at the mouths of Rembrandt's people — he struggled to get that strange expression in his faces that was really there. That artist was not thinking he was God sitting there. Rembrandt, when he had light on one of those faces, you stand and look at these for any length of time, they don't become shadow. They become deeper. That's the difference to me between a Frans Hals or Sargent type of painting and a man like Rembrandt. There's emotion in Rembrandt, something terribly monumental — for eternity.

If you have both love and hate, then you've got it. It's getting down to fundamentals. I think if you have double meanings, then you're onto something. That's the future to me

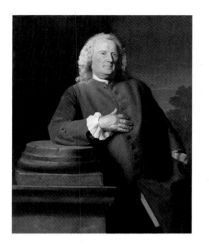

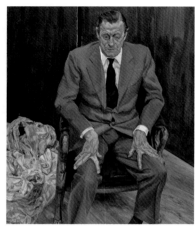

John Singleton
Copley, *Epes
Sargent*, c. 1760,
oil on canvas,
National Gallery of
Art, Washington,
Gift of the Avalon
Foundation

Lucian Freud,
*Portrait of
H. H. Thyssen-
Bornemisza
(Man in a Chair)*,
1985, oil on
canvas, Thyssen-
Bornemisza
Collections

Up in the Studio
[the artist's sister
Carolyn], 1965,
watercolor and
tempera on paper,
The Metropolitan
Museum of Art,
Gift of Amanda K.
Berls, 1966

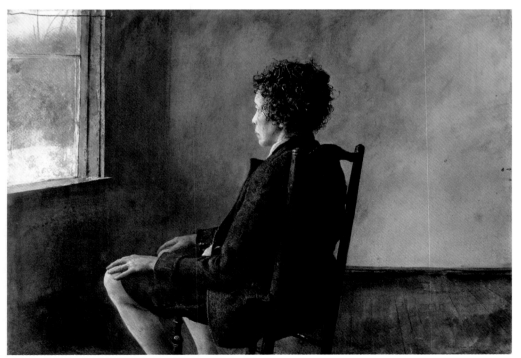

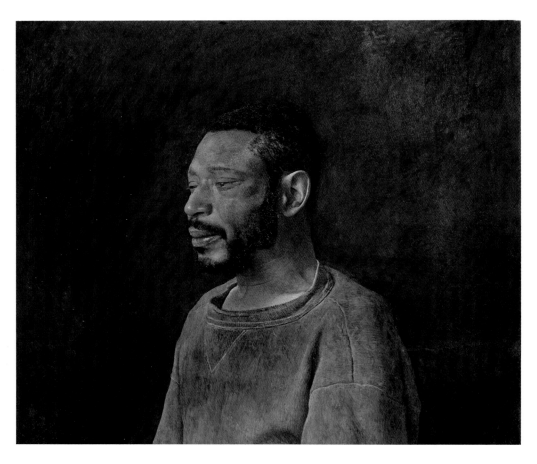

Grape Wine, 1966, tempera on Masonite, The Metropolitan Museum of Art, Gift of Amanda K. Berls, 1967

Pablo Picasso, *Three Musicians*, 1921, oil on canvas, The Museum of Modern Art, New York, Mrs. Simon Guggenheim Fund

Rembrandt van Rijn, *Saskia van Uylenburgh, the Wife of the Artist*, probably begun 1634/1635 and completed 1638/1640, oil on panel, National Gallery of Art, Washington, Widener Collection

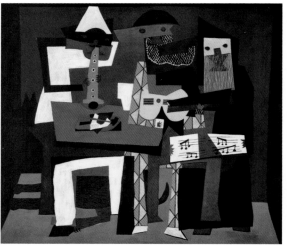

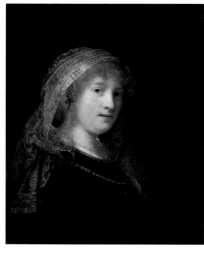

of a work of art, what it's gotta have to really make it sing forever. But if you don't have it, you have a nice scene damn well painted by a man who knows how to put paint on.

I was so moved hearing about Hopper's death. I got to know him quite well. When a person like that goes, a monument falls. He's the only man I know who actually feels that America can stand on its own. We both based our work on actual experiences and things of today in America. It's an indigenous quality. I think Franz Kline had it, even though he's abstract. You're born with it — sometimes a flat quality which is also its primitive quality — the spaces, the placement of figures.

I find I do my best painting when I'm not considering painting — catch that thing out of the corner of my eye, off balance — and I can only catch it if I've lived it. The central struggle is to keep the initial excitement while still looking directly at the subject to draw it in detail. You have to go up to the edge of excitement and not fall over.

> **ANDREW WYETH, LETTER TO EDWARD HOPPER, 1960:** I feel that abstract art and all its cousins is the toughest neighbor that realism has had to put up with for years. Our ideal must be searched deeper and you will always stand with the greatest contemporary power of us all. Wherever one of your paintings hangs, all else fades into triviality…could it be that realism has become paunchy from centuries of easy living. We must not forget our weapons, our paintbrushes.

I think Hopper was the best painter of this generation — the starved depiction of his starved life: wore a trench coat with an old newspaper under his arm, walked to a movie house and back to his studio — a strange dignity to his people — an elemental quality — very simple, very sophisticated, silent power — the way I feel about Christina Olson. The superficial little flighty things go flying out the window. He was almost dull in his power. He never lost the large grasp.

> **N. C. WYETH, LETTER TO HENRIETTE WYETH HURD AND PETER HURD, 1943:** The show at the Museum of Modern Art was beautifully presented, hugely attended by members the opening evening. . . . Hopper was there that night and he and Andy spent a couple of hours together. H— was quite bowled over by Andy's panels and told me so.

62

He once said to me about Ben Shahn, "Don't go near him. He's a basket of worms, that man." When they opened the new American Wing at the Metropolitan Museum [in 1980], Bob Hale gave a cocktail party at his penthouse apartment.* Max Weber, Rauschenberg, de Kooning, Stuart Davis were sitting at a table. I remember Hopper whispered to me, "Those are the conservative painters." At the American Academy of Arts and Letters, Hopper and I had these big medals around our necks. I whispered to Hopper, "How do you feel?" He said, "Like a track star."

He looked at a picture I did once of some sunlight and he said, "You know, I've been working for seventy years trying to get sunlight on a white wall. I can't get it either." It's the hardest because there's not much to hold onto. You think you have it and then it can very quickly disintegrate. You go through all Hopper's trials, all his fine pictures and weak pictures, figures sitting in houses and dunes at Cape Cod, train stations — and finally what do you get, sunlight on a white wall. Can't get much simpler than that.

Great simplicity is complex, and there's a difference between simplicity and vacancy. It's the hardest thing — enrich that sunlight so it actually speaks more than what is on the wall. It's rounded, has depth behind it — breadth. A lot of things are painted at. There's nothing much to hold onto.

It's so important to get the whole character of a thing because then you're sensitive to those little things that happen. That's why I don't like clichés and methods of doing a head or spruce tree or water because those are formulas. Nature's never a formula. That's the trouble with most professional portrait painters. They have a way of doing an eye, doing skin and hair. It bothers me about Copley. Eakins never got that way. I always felt he groped.

I wish I could obliterate brushstrokes, my style, myself. If I could just eliminate the fact that it was done with human hands. I like to work so constantly that I'm unconscious of even my hands or the fact that I have brushes. That's the only thing I have against sometimes doing portraits — the person is there. That's why I hate it when models are looking at me. I'm thinking about what *they're* thinking about me. That's why I like to wear makeup on Halloween. Then it isn't *me* looking at things. That's why I say, "To hell with Andrew Wyeth."

*Robert Beverly Hale (1901–1985), curator of American painting and sculpture at the Metropolitan Museum of Art between 1948 and 1966.

Cooling Shed, 1953, tempera on panel, The Philadelphia Museum of Art, Marvel in memory of Gwladys Hopkins Elliott, 1998

Edward Hopper, *Rooms by the Sea*, 1951, oil on canvas, Yale University Art Gallery, Bequest of Stephen Carlton Clark, B.A. 1903

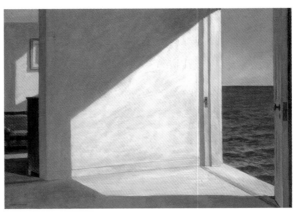

There's not many people that would
spend five months working on a picture.
The intensity builds until it's not a flat
surface to me, until the painting becomes
more real to me than the place itself, and
I live within the picture.

You don't know what you're going to get. Like hauling up a trap — might be ten lobsters or maybe not any. I wouldn't live anywhere else. We get like the country we live in. We have to, in order to survive. You become self-sufficient when you live in a place like this. Go clamming at night with a light on your hat.

You can imagine the way the early seamen must have looked coming into Monhegan Harbor. Jesus! God! It's fabulous to see people like Walt who are still rugged enough to live in that atmosphere. Almost every day we'd row out to hidden-away places, river coves. In the middle of a whiteout fog, you could put Walt ashore anywhere and he'd know where he was. Sometimes we'd stay away for days. I learned how to row standing up. Walt would dig clams for lunch while I did watercolors.

We'd haul traps and steal lobsters that we'd boil. Once we stole ears of corn while the owner was working at the other end of the row. He took me to the docks in the dory where we could get some soup and a drink of whiskey. Or we'd just silently drift. Sometimes Walt would sleep lying in the dory in the sun — like a Viking. I painted *Adrift*, a tempera of that. In the background is one of the shallow reefs where we'd ride the combers breaking over it.

Rarely do you have a chance to see a character like Walt develop. We really grew up together. It's like using the same oar all your life. The oarlock wears it out till there's not much left of it — and you are the one who did it. I tried to give Walt a watercolor of himself. He said, "No, I'll wait till you do a better one."

JIMMY LYNCH: As long as they could be together, Walt and Andy were like children, and the cares and woes of the world weren't on their shoulders. It was total escape. Once a journalist came up and Andy told him that Walt was a retired psychology professor from Harvard, and the guy put it in his story.

WALT ANDERSON: Andy — people — a few that you really care for — I don't know why — it's like falling in love. You don't know why you do. I've known him as long as I can remember. He notices a lot more than most ones . . . barefooted, pants all stiff with paint, find a place and start doing watercolors . . . some days five or six and throw away a lot of them. He used to row at night, in the summertime when

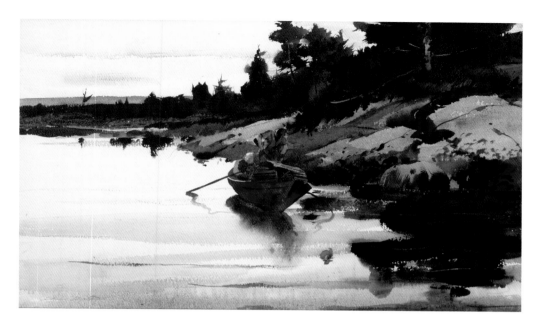

Turkey Cove Ledge, 1939, watercolor and graphite on paper, The Metropolitan Museum of Art, Gift of Amanda K. Berls, 1967

Adrift, 1982, tempera on panel, private collection

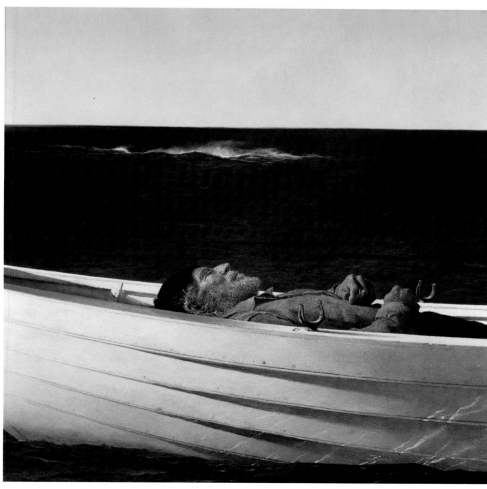

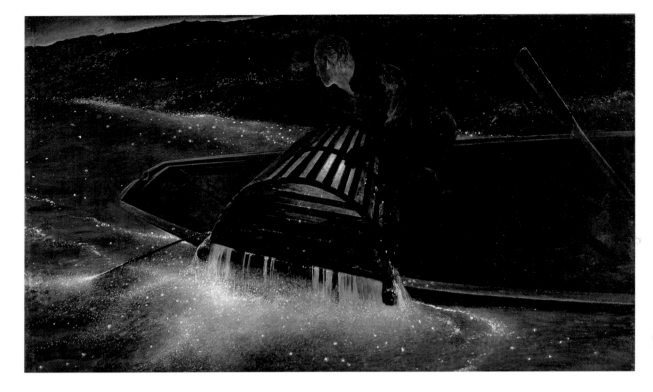

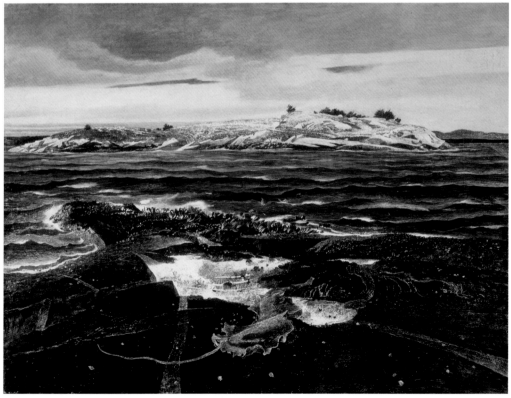

Night Hauling, 1944, tempera on Masonite, Bowdoin College Museum of Art, Brunswick, Maine, Gift of Mrs. Ernestine K. Smith, in memory of her husband, Burwell B. Smith

Little Caldwell's Island, 1940, tempera on panel, private collection

there's no moon — it's all phosphorescent. And he says, "What would it look like with a lobster trap coming out of the water." So we tried one. He was in a dory near me and he said the water beside my dory was white like fire. He said, "I see what I want to do."

That early work was exaggerated, cartoony of the facts — lot of swish and swash. But I think if you took all those watercolors and put them on the floor and walked around, you'd feel you were smelling and tasting the organic color of Maine.

I started using oil regularly in 1934 when I was seventeen. But oil is too heavy — the feeling of paint stopping my expression — didn't like the stubby brushes. I'd get depressed because it would look like a painted thing. I felt the object was so great, why lose it in paint. I remember saying to Pa, "I think it's possible to paint a pair of oarlocks in one of these dories and really make you feel the truth and absolute quality of metal to express all of Maine." That's why I learned egg tempera from Peter Hurd in 1936. Everyone thought I was just wasting my time.

I'm not a juicy painter. Tempera has a cocoon-like feeling of dry lostness — a strange removed quality almost like a ghost. The discipline — very dull — I mean minute strokes — layers the way the earth itself was built. There's not many people that would spend five months working on a picture. The intensity builds until it's not a flat surface to me, until the painting becomes more real to me than the place itself, and I live within the picture. But the wildness is still there, underneath. I think anything that's good has to be out of control for a certain amount of time.

Walt would mix my colors — egg yolk, distilled water, and the paint. I did five temperas. Nobody liked my temperas then. They thought I was crazy. My father looked at the portrait of Walt and said, "I don't know, Andy." Or he'd say, "Andy, can't you add some color to it? No one will ever like them." I told him, "That's not what I'm after, Pa."

ANDREW WYETH, LETTER TO N. C. WYETH, 1940: Yesterday I worked on the sea on my tempera of Little Caldwell's Island. I want this picture to thunder in every part, even in the smallest bit, make it smell with seaweed and salt air and sing with clear, rich, damp color.

Later I developed what I call drybrush that's halfway between watercolor and tempera. I dip a small brush into watercolor pigment, squeeze it out with my fingers, which splays out the bristles. On top of a liquid watercolor wash they leave separate, distinct marks, which can be worked like tempera.

BETSY WYETH IN HER JOURNAL, SEPTEMBER 29, 1940: Andy is so stimulating that I feel my whole soul just a surging wave of ideas, impressions, thoughts. My usual morning visit at Andy's studio found that big tempera finally completed. He has expressed the rich pool of water the tide leaves behind it in a way my eyes have always expressed it to my soul. How thrilling it is to know that Andy sees things as I do.

ANDREW WYETH, LETTER TO HIS MOTHER AND FATHER, JULY 22, 1941: The other morning I got Betsy up at two A.M. and we rowed out to Teel's Island. It was a very clear, still morning with a sliver moon, which made the effect just perfect. The first thing we heard was Hen Teel's dog barking. Then the little square of light through the kitchen window would blink on and off as Hen passed in front of it. The house was built with the timbers of a British man-o-war wrecked there during the Revolution. I've never felt the mood of a place stronger, walking up the path and into the long passageway leading to the kitchen — and then the dim light of a lamp in there. Hen was sitting in his rocker next to the kitchen window. While we talked he would every now and then give one of his quick glances toward the water. It expressed to me the whole feeling of distant islands and waters.

Hen's accent was almost Elizabethan. Island words. Island talk. A lobsterman fell overboard off Teel's Island and I asked Hen if they'd ever found his body. Hen said, "God, I guess not. He's had some soft walkin'." Sounded to me like something out of Shakespeare. Another time he told me, "You know that girl with them air-cooled teeth? I saw her over to port. She had on one slim rig. Went by me with everything humming taut." When he was shown one of my watercolors he said, "Gawd — some slippery with that brush, but ain't it a mess." When he was really quite ill and they asked him how he was, he said, "They tell me I've lost my mind but I don't miss it none."

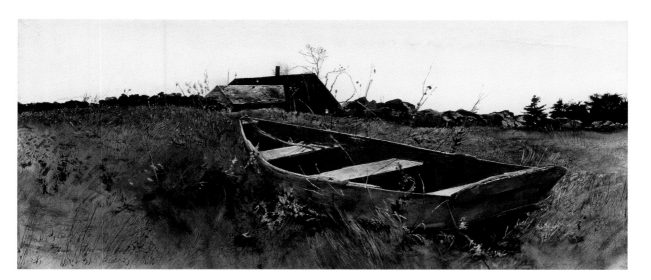

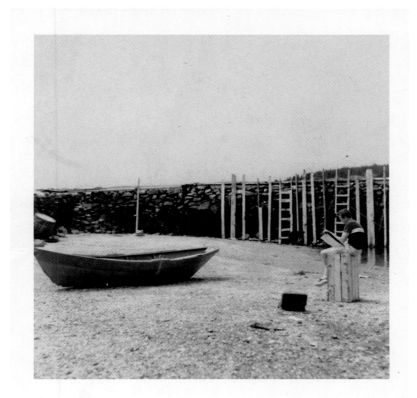

Teel's Island, 1954, drybrush and watercolor, private collection

Photograph of Andrew Wyeth sketching Henry Teel's dory, taken by Carl Dick, July 1950, Currier Museum of Art files

His Boot, 1951,
drybrush and
watercolor, private
collection

Hen would go out early to tend his traps, and I could hear his squeaking oarlocks and the sound of a trap hauled up and let drop down. He knew every bit of water he rowed in so well it was just a part of him. He'd land on the beach, step the oars, and get out all in one motion. The only sound was the sea lapping on the beach and reflected on the sides of the dory — shells on the sand and swooping barn swallows. The dory was like a child to him. I painted it as a portrait of Hen. Called it *Spindrift*.

I must have done a hundred pictures on the island that carried the purely abstract quality that appealed to me — worn by winds and weather — the spindly quality of Olson's place. The aura of Olson's and Teel's gave my mind a chance to play. Silence. I was interested in Hen's oars — sharp and spindly from constant dipping in the water — like an ice cream bar getting thinner and shinier as a child licks it — the feeling of the small bones in Hen's fingers — long and bloated from working in the salt water.

> **WALT ANDERSON:** Hen died in 1954 — in his seventies. Wasn't sick very long. They took him off the island. A month later he was dead. The island after he died seemed as though, when they buried him, they buried something else. Something you couldn't see. Andy mentioned to me about Henry leaving his things lying around as though he was through with them.

I came ashore and there was his boot — a brown mass with the yellow of the sand coming up into it. And as time passed from noon, long shadows came in and I could sense the passage of time — a feeling of motion arrested, violence behind quiet. I painted *His Boot*. He had drawn his old wooden skiff up beyond the tide and it was still there, with the weather-beaten roof and a lightning rod in the distance. I did a drybrush I called *Teel's Island*. I'd stood up on that roof to do sketches for my tempera *Northern Point*. I often thought if I could do his portrait with the drawing absolutely true, then the head would disappear into one of the barnacle-filled ledges of his face — a Teel's Island gray — primeval — went back to Hamlet.

In 1987 I was drawing Walt on a ledge by the tide pools where I played as a kid. He said, "You better hurry. I'm not going to be around long." He had throat cancer. A week later he had an operation and I went to see him every day — had tubes coming out of his mouth and couldn't talk, just move his eyes. They told me he got up, sat on the edge of the

bed, had eggs and bacon and a cup of black coffee, lay down, and choked to death on his blood. After he died I went up there to the hospital with my son Nicky, and he guarded the door so the nurses couldn't get in. I sat with Walt for an hour and I drew him. I'd known him since I was a boy. He's in all these rocks here. He's in the wind blowing. He's in the sea hitting these ledges. I can taste him in the salt water.

Once on Allen Island in early morning light there were fishnets hung to dry — a whole feeling of shrouds — a fateful quality, the eerie feeling of a phantom — the veil that Maid Marian wore. I felt the spirit of something. While I painted, I thought of a young girl, blond hair, who fell in this roaring spout where the surf came in and out, in and out, and where I used to go with my father to watch high seas. It caught her and dragged her in. They couldn't save her, and she floated down past Allen Island to Pemaquid, and they picked up her body eight days later. Her head smashed, eaten by crabs, her body still draped in a long skirt.

I kept thinking of that girl's body floating under water. The nets became her spirit. The nets were like fog. One was made of synthetic nylon and had a bluish cast. I tried doing it with a brush but couldn't get that fineness, that strange cold blue. So I went to a very sharp pencil, scoring into the gesso. The blue is just the pure color of the pencil, and it got that refraction of light on it, the texture. That was a big reason for the painting. I called it *Pentecost* because the early settler, George Weymouth, landed near Pentecost Harbor.

Betsy and I bought five acres in Cushing from Betsy's father and built a house next to the Saint George River. I thrive on nothingness, and Cushing is one of those things that almost isn't. I feel the personal side, the inner introspective side. Basic. Houses perched on the land, might blow away. The farms are secluded — wood piled behind barns next to saw rigs — fields like the sea. Quietness — like country people buried underground sleeping. A quiet, gentle existence. Silence. I'd be painting in a clearing and a foghorn — something far away over the horizon. Intensity. Like finding dead flies on a newspaper twenty years old. Lonely place. Removed. Seamen who had violent lives — gentlemen retired to till the soil in a potato patch. Nobody pays attention, people apart but friendly, time standing still right there, lurking loss and abandonment. New England — capable of burning witches.

Northern Point, 1950, tempera on gesso panel, Wadsworth Atheneum Museum of Art, The Ella Gallup Sumner and Mary Catlin Sumner Collection Fund. Endowed by Kathryn and John P. Britton, 1950

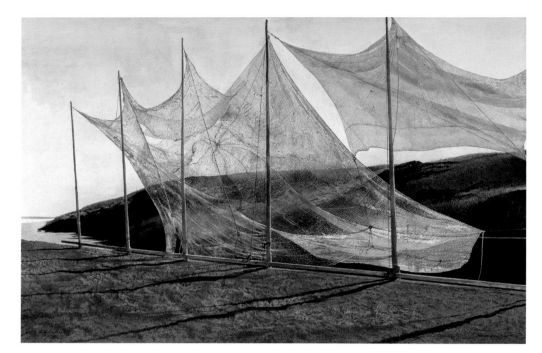

Pentecost, 1989,
tempera on panel,
private collection

Front Door, 1944,
tempera on panel,
private collection

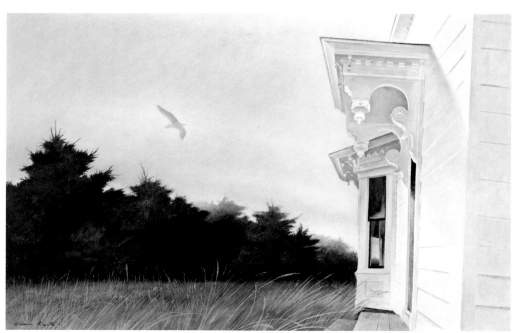

BETSY WYETH: The past and present are constantly swirling in and out, back and forth. Andy talks about intangible speech, the sound of a voice that's not there any more. The sense of history that's gone before. Wars that have been waged. Births. Deaths. Violence. Storms. It's almost as though he senses the ghostlike residue left. He told me once that the Gettysburg Address is still floating around in the air and will be recalled sometime.

One evening in the moonlight Betsy and I were walking beside the harbor in Thomaston. The tides had opened up one of the banks of lime tailings grown over with field grass. It was luminous in the moonlight, almost shocking. White is always that amazing thing to me — the dry white and across that is rich black, and browns, but mostly black with ocher underneath where it dripped over these bits of shells. Like the crown of the king of nature — catching the moonlight — gleaming at the top of this dryness.

There was a board sticking out. Reminded me of the timber of a ship — the thrust of it. When the lime kilns used to burn day and night, everything was covered with lime. Even people's boots where white with it. There was the feeling of the white clipper ships that sailed from that town of Thomaston taking the lime to distant ports. I thought about Fourth of July parades there in Thomaston and watching the way the sun hit the façades of the white houses built by sea captains and thought of the anxious faces in high garret windows, watching for the homebound ships. I was so excited, when I got home I didn't take time to find a piece of paper, just drew the outline of *Lime Banks* on the studio wall to get the mood.

In a Fourth of July parade the marshal was Ralph Cline — this amazing figure. Something about the way he walked, his build, this feeling of very erect. He had on the dark blue uniform of the Veterans of Foreign Wars. That memory stayed with me — almost an illusive memory, too — a suggestion.

Three years later I was doing a watercolor near Ralph's house and he came by and bent over to look — and that face — it was like the evening I saw Spud Murphy — an abstract excitement.

I began calling on him and he'd sit in his kitchen tilting back on a shaky kitchen chair sucking on his spit-clogged pipe and half roaring, "Well, now let me tell you about that." He patrolled the Mexican border at the time of Pancho Villa and in World War I

was a sergeant, was actually in the trenches. I told Ralph about Karl Kuerner. Ralph said, "We probably shot at each other — oh no, if I shot at him he wouldn't be walkin' around."

Finally, he agreed to pose, and then I found out he still had his wwı uniform he was saving to be laid out in. He told me, "When you see somebody alongside of you that you thought a lot of blowed to kingdom come, you see things different. That's why I feel like I do about that uniform."

I sat him down in the loft of his sawmill to steep myself in him — the pitchy smell of pine sawdust and the scream of the saw below us, the thunder of the guns in Ralph's war stories. I dreamed of those newspapers of wwı that I used to pour over as a child in Pa's studio — their smell, the casualty lists, pictures of General Pershing — or Rickenbacker — or Frank Luke the Balloon Buster — or Captain Whittlesey of the Lost Battalion — or even the tunic of the man who was killed in Sarajevo at the start of the war. That could be Ralph's tunic.

He was terribly nervous — and it was tense for me, too. Finally, talking, he'd laugh and this little smile hung on afterward. I moved to the left and he looked out the window, and in fifteen minutes I had a drawing. It was a fleeting expression. Motion holding its breath. Nothing realistic. Didn't look like him. I took it home — didn't show it to Betsy — I was terribly excited about it, very nervous. After supper I just flashed it at her — if a person has time to analyze too much, that deadens a thing. All she said was, "My God, Andy, just terrific — just terrific."

After I get in the mood of a painting, I love to paint the background. It's the most joyous, exciting thing because I dream about this world that's going to live in that background — the thunder of the Meuse-Argonne, the dirt and mud Ralph stood in in the trenches, the smell of the pine sawdust in his mill. There shouldn't be a part of the picture that doesn't sop up the smell of what you're doing.

I often look at my work in the dark, with maybe a moon outside, to enjoy it for the abstract quality. I'd go over to that loft on gray days when we couldn't work and I'd swing the picture away into the dark and look at it from across the loft. All that would show was the white of his head. It could be the head of an American bald eagle. Amazing, here's all this age and the stress of the years. His head is turned — quick. He'll turn back in a moment. His grin is just quieting down, but there's a sadness, too; he could almost cry. His expression is painted completely from memory.

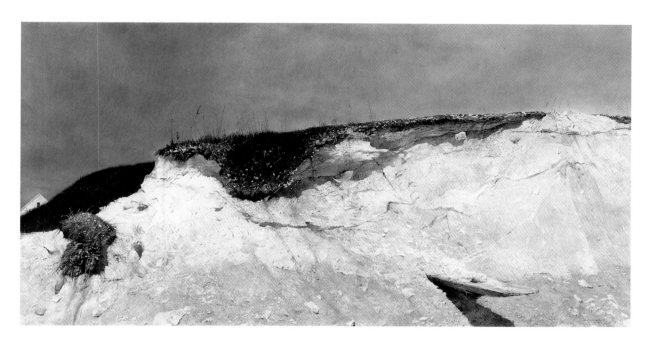

Lime Banks, 1962,
tempera on panel,
private collection

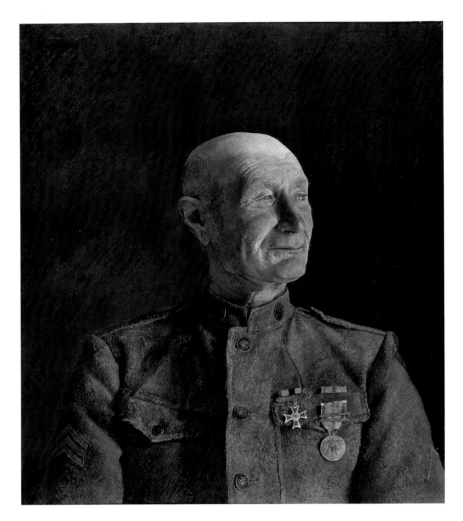

The Patriot, 1964, tempera on panel, private collection

Photograph of Andrew Wyeth painting *The Patriot*, taken by J. George de Lyra, c. 1964, Courtesy of the de Lyra family

Ralph's Maine character remarks finally died out and the truth quietly emerged — great depth, very sharp edge, likes very few people, but such a warm man, such dignity, intelligence — military life was his greatest pride — a type it's very rare to get to sit and be natural with you, especially in Maine.

RALPH CLINE: Andy loses track of time. Could fire a shotgun right under his feet and he wouldn't know it. He kept me talking all the time, but then when I clam up, he'd tell me a story to get me started. Didn't want that ramrod expression. He was so wrapped up in his work, he'd sometimes tell me back stories I'd told him. Everything was marked on the floor. He had the easel at an angle, and if my chair got moved a quarter of an inch he could tell. Sometimes he'd lean back and look and then he'd measure me. I suppose I'm the most measured man in Knox County.

When it was pretty near done, he took my wife up and she takes one look and starts crying. That's the only way, you know, women have of expressing their emotion. I think Andy got in this picture something I don't see in the mirror. Andy come pretty near being a Maine native, come right down to it.

The loss of someone very close to you — probably the most intelligent man I've ever known — does something that you can't get any other way. His death shook me to my foundation. I think it lifted me out of being an "artist" into actually facing life, not doing caricatures of nature. It gave me a *reason* to paint.

Ever since I was about eight, I've wandered over this little territory right here in Chadds Ford, looking at things, just being alone, perfectly to myself. Pa kept me almost in jail — just kept me to himself in my own world and he wouldn't let anyone in on it. I realized, "Jesus, where am *I*!" He was a great father, generous, had time for all of us. He noticed. I was crazy about him. But he had this dominating side.

I went undergound when I was around fourteen. I got such an urge to really *do* something. I had this feeling since I was twelve. I felt so left out from other kids. They all went to school; had many directions to travel. I was a homegrown product. I couldn't even spell. It took me a long time to read well. Art was the only thing. I had a real compulsion to paint. The only time I am really content is when I am completely alone and painting. I was driven partly by self-protection. Otherwise people are picking at me, dragging me. I've got to have my freedom. I've got to have it. I will *not* be tied in!

> **BETSY WYETH:** He would never wear a wedding band because he thought it was too confining. He didn't like my pregnancy — he'd walk a few steps apart from me on the street because he felt it stamped him, took away his individuality. He doesn't want to BE anything.

I was about eight years old when I began slipping away up through the woods behind my father's studio. Above those trees starts a long ridge — like a spine — all open farm country. I've walked it all my life, wandering this little territory perfectly to myself, very much alone. There's such a gap between a country you just see with your eyes, not your soul, and what you feel beneath the surface. I was born in Chadds Ford. It's like a mother and a father. Sometimes I think I would have been stronger if I had stayed in one place. This is a great weakness in me because I get great satisfaction out of Maine, too. I feel sometimes that I'm a man with two mistresses. I don't know which one I love the most.

Sometimes, wandering — sometimes I don't even know I'm walking; don't even know I'm there — it's a place I've played in, known well. Just being quiet in a cornfield on a windy fall day and listening to the dry rustle and seeing what goes beyond the fact — I feel completely away from things. I walk through the rows of blowing corn. I'm reminded of the way a king must have felt walking down the long line of knights on horseback with banners blowing.

Back Way, 1982,
watercolor on
paper, Rahr-West
Art Museum,
Manitowoc,
Wisconsin

Adam, 1963, tempera on panel, Collection Brandywine River Museum, Gift of Anson McC. Beard, Jr., 2002

Once the crows and other birds seemed to be blowing instead of flying through the air. The sky made the ground move. Someday to put this in a painting is what I long to do. Such pure color seemed to blow all dull things from my mind. I love to see the changes the months bring to the landscape. I prefer the winter — the bleak quality — the different moods of light, the dead feeling. The whole story isn't shown — people stay indoors and I'm left alone. Snow has a strange effect on me. When it starts to fall, I'm absolutely intoxicated. If you listen intently, you can hear the strange sifting, the quality of rich earth soaking up bits of snow coming down, the snowdrifts and the shadows across them. There are so many moods of white — a great deal of warmth. And then little islands of dying winter making the earth so rich in color. Makes me go back more into my soul.

In the middle of a field was the head of a deer with antlers half buried in the snow. The eyes were so sad in death — the frozen footmarks of geese with snow sifted through them — like something out of Egypt, hieroglyphics, the texture light and dark. Rabbit tracks. There was the feeling of life beginning to stir, the gleam of lights in the houses of the Negroes that lived along the ridge, the sound of Adam Johnson's pigs as I passed some outer sheds of his farm.

Adam told my brother Nat, "Andy was a kid when he started painting — a baby, maybe fourteen — and he said he was going to make his living doing this and could he draw me sometime. Andy got the glory of painting and he won't get nothin' else. I got the glory of cuttin' grass and I won't get nothin' else."

I gave Adam one of my first temperas and later I noticed a few inches along the left side were gone. He told me, "Oh, Andy, I found a frame in the dump. Looked so good. So I just sawed the picture off and it fit fine." Later I did a big tempera of him in front of his pigpen with a flight of grackles shooting up behind him. I never think a primitive quality is a bucolic thing. He could have been a Mongol prince — or Old Kris coming toward me, with all those jingles and safety pins and things on him. I think Negroes are a very subtle people — maybe it's not possible for white people to comprehend. That's why I think they've been missed in painting. I paint them because they are my friends. Like Adam once said, "Andy and me have friendship. Everybody like Andy, be no trouble in the world."

When I was a kid I used to go to the end of the ridge to Kuerner's hill. I tobogganed down it. Rolled down it. At the top are still three little pines, and I loved to sit under them and hear the soughing of the wind. It reminded me of when I used to lie under

the Christmas tree and look up into the branches. Below the hill is the train track that swings up toward Philadelphia. Two weeks before Christmas I'd go with my mother and Ann — that's when I picked out lead soldiers — and the train would sort of shake going by the Kuerner farm. It was like the farms that Ann and I made in the dirt and I marched my toy soldiers.

The German quality of Kuerner's appealed to me. In my father's studio in the little entry room was an engraving of a Swiss-German town named Thun with steeples and a lake and faraway snow. I would study it for an hour, imagining what it was like. That was where my father's French-Swiss grandfather and German-Swiss grandmother were married. They moved to America and had greenhouses in Needham, Mass. Pa had stereopticon slides of Switzerland that my sisters and I watched over and over. Pa told us stories about the Alps, how his Swiss relatives' hobnail boots were so heavy they wore out the Alps. When I was four Pa moved us to live in Needham to be close to his mother, who was a wonderful woman — so I heard a lot of Swiss German. I can remember enormous bowls of soup put in front of me. I remember bursting into tears because I didn't think I could eat it all.

The Kuerner farm became the touchstone of my Chadds Ford life. I was thirteen when I got dressed up and went to the Kuerner farm and asked Karl Kuerner if I could paint there, and he said yes and told his children not to bother me. He always treated me . . . that I was not just a child. It was marvelous. In the late afternoon the Brown Swiss cattle would come down to the barn — the hollow sound of their hooves. And his wife Anna would be outside talking to herself and sweeping up the dung. And Karl would stand in the barn door and he'd tell me things. In later years after work we'd sit in the house and drink beer and his hard cider.

He told me about being a machine gunner in WWI cutting down soldiers and how he fought at Verdun. He'd hide in shell holes and was wounded, and he showed me the scar on his arm and pictures of the war. He told me, "You haven't seen anything if you haven't looked into the eyes of a Prussian general." It was *The Big Parade*. And all my war games.

In my studio I still have my collection of toy soldiers in German uniforms, made in Germany around the end of WWI. In my father's studio was a German helmet I'd put on and army uniforms. In the entryway was Pa's collection of rotogravure newspapers about

Wolf Moon, 1975, watercolor on paper, private collection

Brown Swiss, 1957, tempera on panel, private collection

WWI and I'd pour over them. I felt if I could get that quality into my work with the clarity a good military man must have, then maybe some day I could paint a good picture.

My painting evolved so much around Kuerner's. I painted there for decades. Going back and back to a place you know very well adds another dimension. Your imagination has a while to play. I've watched Kuerner's in the evening from the top of the hill, seeing the lights go on in the house. And I know Karl's going to bed, going up the stairs, his shadow going by a window. You see lights going off and you can practically see the whole — what he's thinking, what he's doing. I love small windows, looking in or out, the glimpse of a landscape stirs your imagination if you don't see too much.

Once I stopped the car by Karl's orchard and sat there looking at the evening light, and all of a sudden I heard rustling. I turned on my headlights and here was a deer behind this tree with its head reaching out to me, deep blood-red eyes. This could have been a reindeer; it was around Christmas time and I kept thinking this could be Old Kris' house in the north. It stayed in my mind. The next morning there was the deer strung up in the barn. So I painted it. A strange picture. Tree limbs became the antlers of the deer. Betsy saw the picture and said, "That's nothing but death."

Each evening Karl walked around the farm hunting groundhogs and possums and skunks. He cut up them up and fed them to his dog. Each fall he went to Canada hunting moose and deer and cut them up into four quarters that he drove home in his truck. Nothing was allowed to go to waste. Everything was used.

Karl Kuerner had one side that was marvelous — understanding and wonderful. That saved him — but he was undoubtedly the most brutal man I've ever known. Kuerner's was basic farming. I've been there when he's pulled a live pig up with a block and tackle and then stabbed it with a knife and split it open and let the blood drip into a big barrel below.

Once a heifer was so narrow it couldn't get her dead calf out. Karl lay down and reached inside the heifer with a knife and cut up the calf, pulled it out piece by piece. He told me, "When the head came — that was the worst thing I ever come across. But I saved the heifer."

KARL KUERNER: Not unusual for a farmer. That's how we live. City people — everything comes in a package.

Cornflowers, 1986, watercolor on paper, private collection

Dead Buck, 1957, watercolor on paper, private collection

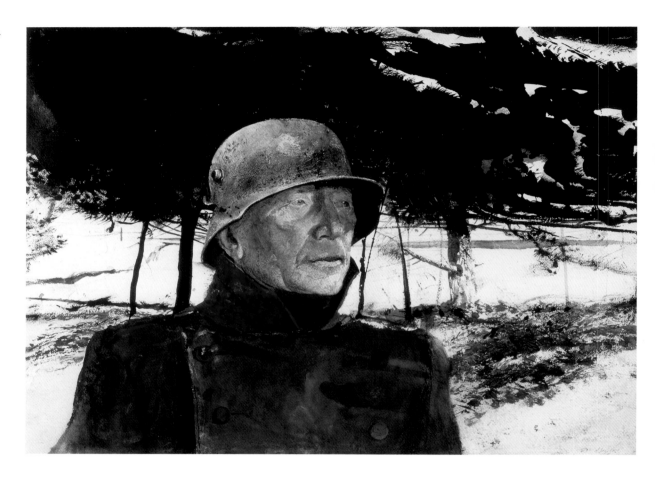

The German,
1973, watercolor
on paper, private
collection

I did a watercolor portrait of Karl — *The German* — his lips are my father's — brutal — dangerous.

> **LOUISE KUERNER:** Daddy could be just as gentle as he was stern. Felt very deeply about things. No matter how miserable we thought our lives were, we girls always gravitated back to him.

I could go anywhere. The coolness of the entry room, the plainness, the scrubbed linoleum seemed out of my Swiss-German background. In the attic I found a lamp there with burned matches — wondering who used it and why, and feeling my own mortality. In the barn was the trough — the water starting on the hill, the snow seeping into the ground, running down pipes through the house and into the trough, like life itself endlessly moving. Somebody far away might be on their way to this place for a drink of pure water; Christ may have drunk here. There was a swirl of light on the steel milk bucket against the snow on the hill. Through the window, a sense of foreboding.

I painted this in *Spring Fed*. It was really how I imagined the death of Robin Hood. He has been taken to a nunnery and locked in a room and bled for a day and a half. His band hears a faint trumpet that leads them to the nunnery. Little John breaks down the gate by throwing a huge rock, which to this day has not been moved. He gets to the door, flings himself against it, and inside is Robin Hood in a pure white room on a stone slab, the blood from his veins running down the side of the slab and his helmet by his head.

To me, *Spring Fed* shows death was the only thing that killed Pa. The train couldn't kill him — death did. He really is dead and will never come back. I was in Maine when I got the phone call that my father and my brother Nat's son, Newell, were dead.

> **BETSY WYETH:** Andy looked like Hamlet speaking to his father's ghost. It was as if he saw something I didn't see, standing there all alone. He was seeing death. I remember waking the next morning and Andy was by the window sobbing. Crows were cawing. There was no touching him.

Pa was on his way to Archie's corner to pick up Evelyn Smith to clean my studio, where Betsy and I were living. First he picked up little Newell for company. The road went across the railroad right next to Kuerner's. The car stopped on the tracks just as a train was coming. There was no whistle. I talked with the engineer, and of course they never tell

you the truth, but he told me, "Your father looked toward us and I saw him throw himself over the child." After the wreck they released the steam and the whistle kept blowing and echoed off the hills. It was announcing the death of N. C. Wyeth, who had painted all those knights sounding their blasts on bugles. An old black woman told me, "The killer's voice was blowing all morning."

Betsy and I rushed down from Maine. I drove alone to the Quaker Meeting House next to where he would be buried. I went into that meeting house with leaves blowing across the floor where the blood — there were brown stains where a Hessian soldier's legs were amputated after the Battle of the Brandywine — and the two open caskets. The sun was beginning to set. Outside was the sound of dogs barking far away and roosters crowing.

There was little Newell in his casket, fair-haired, very handsome, with a white and blue sailor suit on and a silver whistle around his neck. In the casket next to him was my father, lying there. Amazing, broad face, looked almost Indian — black grizzly eyebrows — hair sort of parted slightly in the center. I was amazed by the smallness of his hands folded on his chest and the delicacy of his nose. Their faces had become masks of eternity. Years later I painted that look — my model Helga Testorf asleep in the total blackness of a closed coffin in Pa's old studio where three death masks hung. I called it *Night Shadow*. It was Pa in his casket when I bent down and kissed him on the lips. Cold and waxy.

I stayed for an hour, my spirit raised so I was sort of hovering above — a strange feeling, sort of sublime in its way, amazing. I was grateful that up in Maine, a few days before Pa went back to Chadds Ford and was killed, I had a new watercolor — Henry Teel's pants with suspenders hanging, and looking by them into the kitchen. We got talking about painting. Stayed up until three in the morning. He was so complimentary about my watercolor, but he worried that I could never make a living out of the realism I believed in — thought the art world had completely reversed.

He was floundering in his own work, sort of lost heart. He was trying to find other ways to do his painting, to fit in, be modern. He would pick up some little tidbits and tendencies of modernism and build them in his mind. He was working from his imagination in these illustrations, and that makes you much more open to ideas from other people.

N. C. WYETH IN A LETTER: What magic powers that boy has!

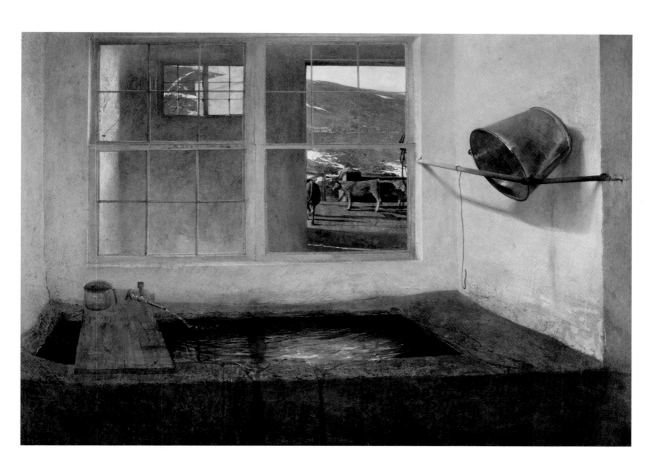

Spring Fed, 1967,
tempera on panel,
private collection

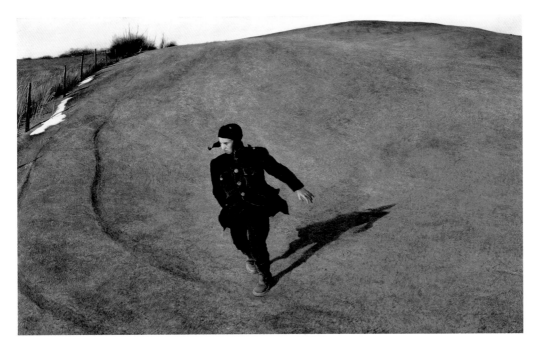

Winter, 1946, 1946, tempera on board, North Carolina Museum of Art, Raleigh, Purchased with funds from the State of North Carolina

Study for *Karl,* 1948, watercolor on paper, private collection

I told him what I really felt about his work. I told him, "This watercolor is nothing compared to what you can do. You don't realize what you've done. You've created the greatest paintings. Whether they're illustrations doesn't matter. They're what the absolute romantic vitality in painting can do. You made a landmark." He laughed at me. But thank God I gave him a complete worship of his own qualities. He was a creative genius. He did over 2,000 paintings — murals, portraits — and more than 1,300 illustrations.

The loss of someone very close to you — probably the most intelligent man I've ever known — does something that you can't get any other way. His death shook me to my foundation. I think it lifted me out of being an "artist" into actually facing life, not doing caricatures of nature. It gave me a *reason* to paint. I wanted to get down to the real substance of life itself — a terrific urge to prove that what he had started in me was not in vain. I had to have something to pound on.

I was emotionally at rock bottom. I saw the country even more simplified and somber — symbolic. One of my earliest watercolors was those trees on the Kuerner hill. Out of that developed a painting I called *Winter, 1946*. I saw this kid, Allan Lynch — he comes down the hill, running, like a rolling stone, sort of topsy-turvy. And I thought, "that black shadow — like the eyelid of night — that pale face — there's a little safety pin gleaming — patches of snow, dying winter." It was me at a loss. Allan's hand drifting in the air was my free spirit, my hand almost groping, really, disconnected from everything. The bulges of that hill seemed to be breathing, rising and falling, almost as if my father was underneath them. I feel my father alive all around me. It's like taking a draft of rich cider.

When I walked across the railroad tracks where the train hit Pa, I came to Karl Kuerner's house. Now everything seemed clear and focused for me: "My God, get to work and really *do* something." I was up in Karl's attic room I used as sort of a studio and was painting the German smoked sausages hanging from one of the iron hooks in the ceiling. [The hooks] had been there since the American Revolution. Karl and my father looked strangely alike. They had somewhat the same Germanic background. It was the closest thing I knew to a power. I was terrified of my father as well as loved him. That's where Karl was the image of my father. There was a bite there — dangerous — not to be fooled with. The hooks expressed his personality to me — also my state of mind.

BETSY WYETH: Really, when Karl comes out of the barn, it's just astonishing to me. He's a much smaller man than Andy's father, but you can imagine a massive Karl Kuerner. He has a way of looking at you — a sideways look that just shatters me, the resemblance. Amazing. And then the high voice. That is so eerie, what they look like.

Karl was sitting there and suddenly reached up and grabbed a sausage off a hook. I started out drawing profiles of him under the sausage. But the studies didn't have that core, the essence of what I felt about him. One day he turned his head and looked at me and I thought, "Christ, *there* it is."

It dawned on me that I had never painted my father. I'm still sick that I had never painted my father. So many things I'd missed. Those subtle things that go by. It's just that you're blind. Why the hell didn't I ask him? I was pretty young. Twenty-eight. Callow youth. I kept thinking about that train whistle blowing and blowing — heralding the death of this — really the pinnacle of what the Wyeths stood for. While I was doing the picture I was almost hit by the same train that killed Pa. I even had *that* experience! I was thinking about the picture and just going to drive across the track. In the last second I jammed on the brakes and the train went firing by me. It could have happened a second time.

HENRIETTE WYETH HURD: Andy talked in a whisper about how his father's cheek felt when he kissed him in the coffin. And that was what he thought about when he painted Karl under those hooks. The light came across Karl's face the way he remembered Pa's face had been.

I'd feel Karl's face and say, "God damn it, why can't I get this hardness!" It was god damn cold in that attic. My hands were so numb I could hardly hold my brush. Karl kept us warm with a jug of hard cider between us. He took his with a rum chaser.

One night I took home all the studies, profiles in many positions, about twenty-five, and laid them out on the floor and talked about them with Betsy. She's been the making of me, no doubt about that — gives me a kick in the pants — just what I needed. She takes in detail, picks weaknesses very quickly, great feeling for detail. A lot of wives — you might as

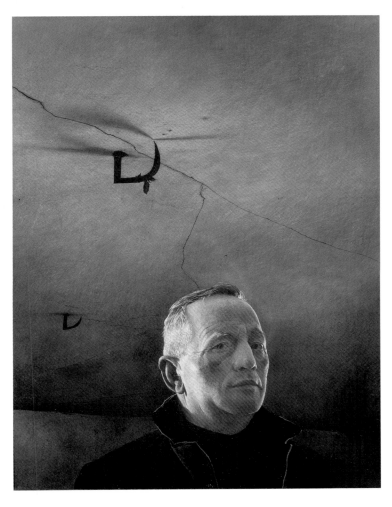

Karl, 1948, tempera on panel, private collection

Photograph of Andrew Wyeth in his Chadds Ford studio with his painting *Karl*, taken by Arnold Newman, April 16, 1948. Courtesy of Arnold Newman/ Getty Images

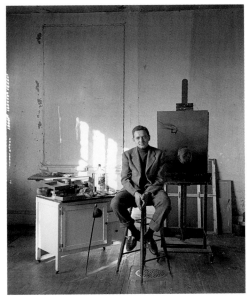

Anna Kuerner,
1971, tempera
on panel, private
collection

well be showing the work to a gnome. I went and married a girl who became stronger than my father.

I finally figured out that what I was *really* interested in was Karl's head smack down low and just those hooks, which were the way I felt about him. During a thunderstorm and lightning, I'd suddenly see the shapes of those damn things illuminated and shadows circling them. The cracks in the ceiling were like shots of lightning. Talk about abstract power! That was a beginning of the whole transition in my work.

It was one of my first real portraits, and I painted the tempera of Karl alone in my studio where I could just dream. I worked on it a month, and took it back to Kuerner's to be sure I had the ear just right. Pa once told me, "When you paint that ear, you're painting something pulling in all the information from the world, and its feeding a brain that's never been equaled. You've got to get that into that ear." You start to caress it too much and before you know it you've lost some of the edge of the character. I wanted it to seem almost alive — it was listening so hard to hear what Anna Kuerner was doing.

When I finished *Karl*, I took it back to the attic room overnight. The next morning it was gone. Karl woke up in the night hearing footsteps overhead. He found Anna down in the barn with an ax in her hand yelling at the picture — the husband that wouldn't answer her.

When Karl died, we distributed his bones on that hill. And I got a couple of his bones in his helmet I kept. That's what painting has been to me — following the life at that farm with its abstract, almost military quality — following a long thread leading like time to change and evolution. Nothing I've ever done has scratched the surface of what I want to do.

In the Studio

Andrew Wyeth worked for nearly seven decades in the Chadds Ford studio pictured in these pages. As newlyweds, Andrew and Betsy Wyeth set up house here, just a short distance from N. C. Wyeth and the home in which Andrew and his siblings grew up. The white clapboard and stucco structure, formerly a schoolhouse, eventually became a studio where Andrew Wyeth carefully guarded his highly private working space.

The photographs of this space shown here and throughout this book were taken in the years since Wyeth's death in 2009 and give a sense of the environment in his studio, where the artist kept a multitude of books, photographs, and props — including a large collection of toy soldiers — that aroused memories and emotions and fed his creative work.

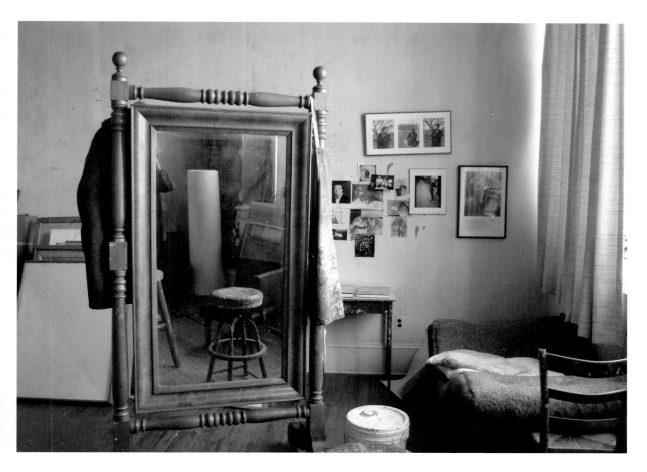

Betsy hung family photographs (left) in a private stairwell of their home. The photographs posted in Wyeth's studio are his own; the one of Betsy (right) is from a *Life* magazine article on Wyeth by Richard Meryman.

Wyeth used the mirror to view his pictures in reflection, jogging his perception of a work in progress. This room was a kind of inner sanctum and was off-limits to almost everyone. Isolating his painting environment was key to Wyeth's practice, preserving his emotional vision uncorrupted.

Wyeth's brother-in-law Peter Hurd introduced him to fencing (facing page, top), an interest that may have related to Wyeth's childhood fascination with warriors. One helmet is a duplicate of Karl Kuerner's (see page 94). The bottles on the windowsill contain Wyeth's powdered tempera pigments.

A former class-
room in the
schoolhouse
became part of
Wyeth's studio.

The skeleton
(above left) is likely
the one Wyeth
sketched when
studying under
his father.

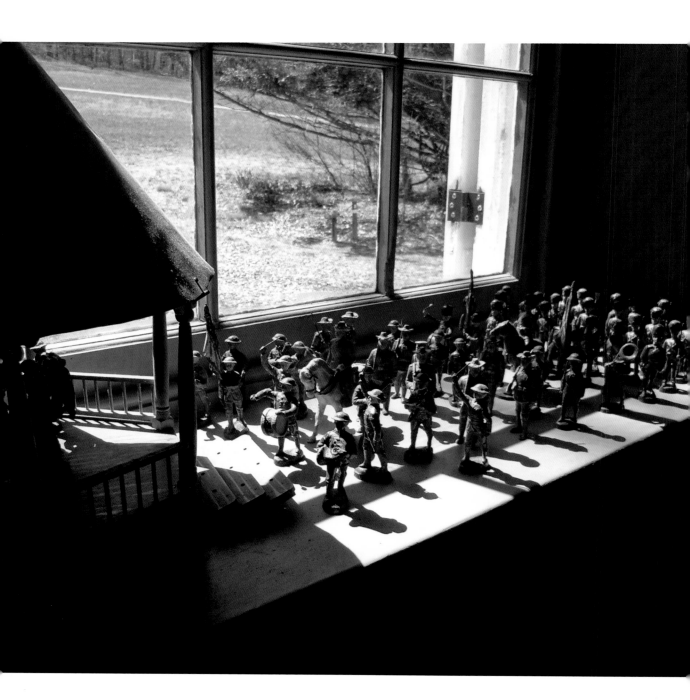

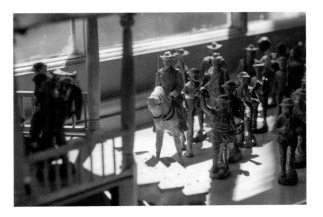

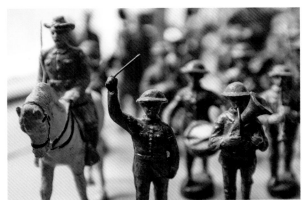

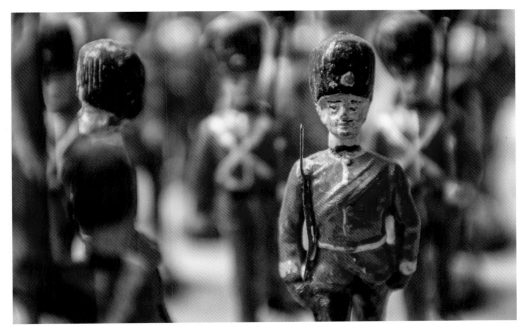

Wyeth's collection of toy soldiers played a vivid role in the world of his imagination as a boy (see pages 30 – 31).

His film reels include *The Big Parade*, a treasured film since his boyhood (see page 90). He still watched it as an adult.

Pages 118 – 119:
On the easel is
Wyeth's 1958
painting *Raccoon*,
a portrait of
a coonhound
named Jack that
he saw chained
at Brinton's Mill,
not far from the
artist's home.
Hanging nearby
are a few of the
many studies he
used to compose
the painting.

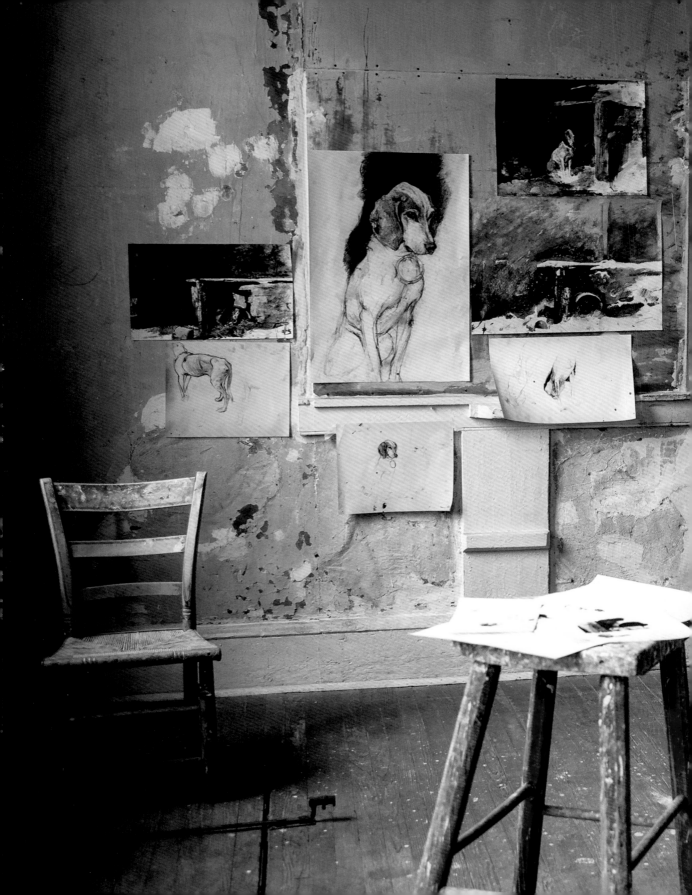

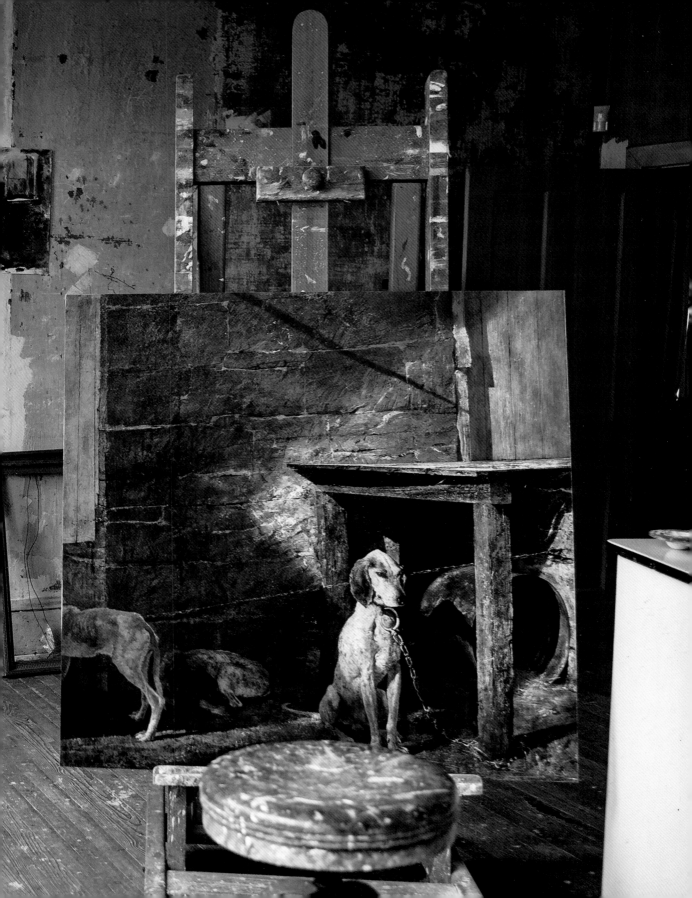

Acknowledgments

My heartfelt gratitude goes to the staff supporting the partnership of Andrew and Betsy Wyeth. Throughout my forty-nine years of researching numerous Wyeth projects, they have willingly shared with me their observations and their understanding of this complex and gifted American artist and his work. Special thanks go to Mary Landa and Karen Baumgartner, who have overseen the Wyeth collection for many years. As I was composing this book, Ellen Layman at the National Gallery of Art volunteered to listen to hundreds of hours of Wyeth interview tapes and pick out material never published before. I owe her a great debt of thanks. These new transcriptions have been interwoven with previously published material, enhancing our appreciation of Andrew Wyeth's artistic method and the relationships and experiences that inspired him. I would also like to thank Nancy Anderson, head of the department of American and British paintings at the National Gallery of Art, for championing the publication of this book. My gratitude extends to Judy Metro and Chris Vogel for overseeing the book's creation with help from their colleagues Ulrike Mills, Tam Curry Bryfogle, and Sara Sanders-Buell.

I am grateful to all those who have helped to bring new insight to the life and art of Andrew Wyeth, a longtime friend and master of a uniquely affecting expression of American realist art.

Richard Meryman

Index

Note: Works of art by Andrew Wyeth are listed by title only. Page numbers in bold type indicate illustrations.

Photography Credits

Photographs of Andrew Wyeth's studio facing page 1 as well as on pages 108–110 and 112–114 reproduced courtesy of Richard Meryman; those on pages 6–7, 104–107, 111, 115–119, and the endpapers reproduced courtesy Brandywine River Museum, © Carlos Alejandro.

frontispiece: © Peter Ralston, 2013 — *www.ralstongallery.com*

pages 8 (detail) and 11 (top): Digital Image © The Museum of Modern Art/Licensed by SCALA/Art Resource, New York

page 15 (bottom): Farnsworth Art Museum

pages 16 (bottom); 59 (top left), 60 (bottom right): Image courtesy of the Board of Trustees, National Gallery of Art, Washington

page 24 (bottom): Kosti Ruohomaa/Black Star

page 44 (top): © Brandywine Conservancy

page 52 (top left): The Philadelphia Museum of Art/Art Resource, New York; © 2013 The Franz Kline Estate/Artists Rights Society (ARS), New York

page 52 (top right): Photography © The Art Institute of Chicago

page 55 (top left): Digital Image © The Museum of Modern Art/Licensed by SCALA/Art Resource, New York

page 55 (top right): © 2013 Milton Avery Trust/Artists Rights Society (ARS), New York

page 56 (top left): © RMN-Grand Palais/Art Resource, New York; Photographer: Thierry Le Mage

page 56 (top center): Image courtesy of the Board of Trustees, National Gallery of Art, Washington

page 56 (top right): Erich Lessing /Art Resource, New York

page 59 (top right): Thyssen-Bornemisza Collections

pages 59 (bottom), 60 (top), 69 (top): Image © The Metropolitan Museum of Art

page 60 (bottom left): Digital Image © The Museum of Modern Art/Licensed by SCALA/Art Resource, New York; © 2013 Estate of Pablo Picasso/Artists Rights Society (ARS), New York

page 63 (top): The Philadelphia Museum of Art/Art Resource, New York

page 63 (bottom): Yale University Art Gallery/Art Resource, New York

page 70 (top): Digital photography by Peter Siegel

page 77: Wadsworth Atheneum Museum of Art/Art Resource, New York

page 101 (bottom): © 2013 Arnold Newman, NY

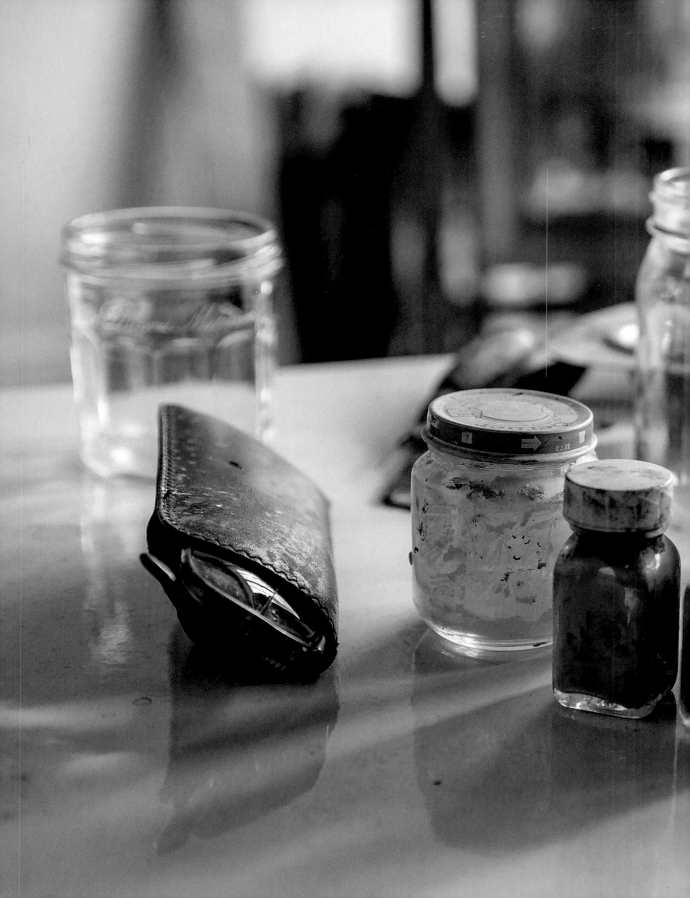